Key

Art

Terms

for

Beginners

Key

Art

Terms

for

Beginners

By Philip Yenawine

Harry N. Abrams, Inc.,
Publishers

Contents

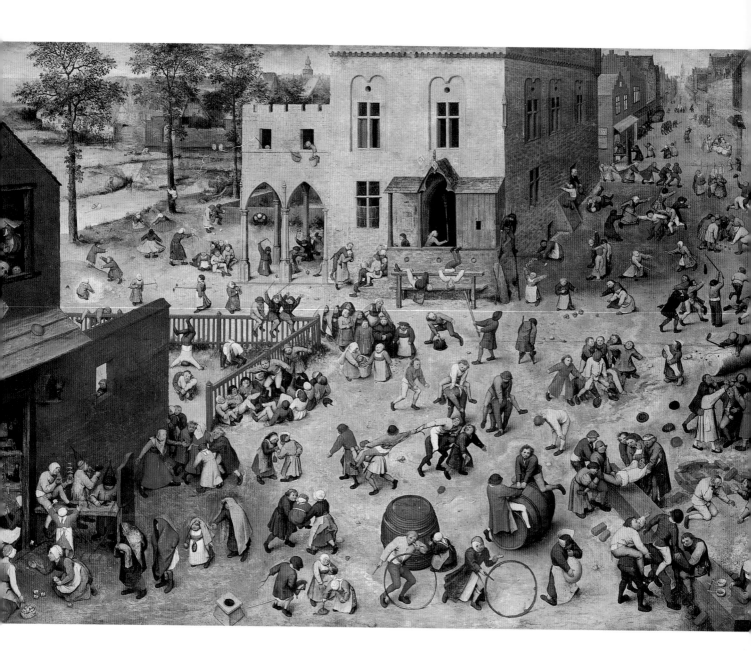

Getting Started

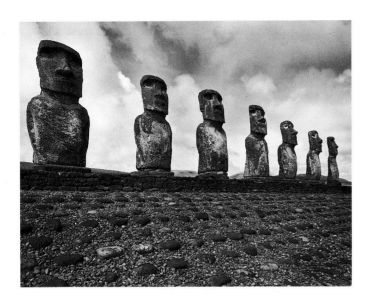

Stone figures. Easter Island, South Pacific. 17th century or earlier. Height 30'; weight c. 16 tons each

It is not known what purpose these figures served when they were originally carved from stone and placed on a small volcanic island facing out to sea (some scholars of **Oceanic** *art believe they are ancestral figures). What we can be sure of is that they have a considerable power—which comes from their scale, their simplicity, their number—and that they testify to the human need to use visual means to express the otherwise inexplicable.*

Opposite:
Pieter Brueghel (Flemish, 1525/30–1569). *Children's Games (Kinderspiele)*. 1560. Oil on panel, 46¹/₂ x 63³/₈". Kunsthistorisches Museum, Vienna

The painter Brueghel was a great storyteller. By examining the people he painted—what they are doing, where they are, how they dress—we find a rich and robust tale of history and human nature, a fascinating **genre** *scene.*

About This Book

This book was conceived for newcomers to the world of art as a brief introduction to terms encountered regularly in art galleries and museums and in books about art. The selection presented is not comprehensive but defines key words as they apply to art, especially since many of them are used often in other contexts. For example, art historians use the word **classical**[1] in a strict sense to refer to the art of classical **Greece** (480–400 BCE)[2] or in a general sense when referring to the civilizations of both **ancient** Greece and **Rome**. In common vernacular, meanwhile, we often use "classical" to mean something good enough to be regarded highly for a long time, if not forever: a "classic." It is sometimes misused to mean "serious," as in the way it can refer to all sorts of music of a serious tone. There are many words like this: **Baroque** to mean anything ornate or **Gothic** to mean slightly horrify-

1. In cases where information about related terms might be helpful for a fuller understanding of an entry, words have been printed in **boldface** to indicate they—or a close variation of them—are defined elsewhere in the book. Check the index to find the section in which they are located. If two words in sequence are in boldface, it might mean that each is defined separately.

2. Because this book includes terms outside the Judeo–Christian **tradition**, the designations BCE ("Before Common Era") and CE ("Common Era") are used instead of BC and AD.

ing; again, here they are presented in the way they are used "within the field."

Most of the terms included here are likely to be used in art institutions oriented toward the **Western** world. Therefore, while the book tries to be inclusive, many of the terms address the arts of Europe and the twentieth century.

Also reflective of museum practices, the book includes some broad designations for what are really very complex categories. For example, a museum may combine a small but varied group of objects from several different Asian **cultures** into a single gallery and call the collection "**Asian** art." Such designations are necessarily very general, and the definitions given here are intended to provide direction for pursuing more specific information.

A Few First Words

It may be helpful first to think about the following broad art-related terms in order to make good use of this book:

Aesthetics

From a Greek word referring to a branch of philosophy concerned with the study of beauty. **Ancient** philosophers determined that a work of art could be studied and judged on the basis of its beauty, or how it pleases the viewer. Theoretically, this should be an absolute standard. What "pleases the viewer," however, clearly differs from one culture to another and changes over time. Aesthetics are now normally studied as specific to a period and place.

The usefulness of the term during the modern era has been debated because so much of what artists made had little to do with beauty in any conventional sense. **Modernists** were as likely to find beauty in ideas as in form and often avoided conventions that appealed to the eye in order to address topics that are not very pretty—such as modern

warfare. At present, the term is used to refer not so much to beauty as to philosophical questions concerning art, such as, What is beauty? or, What is art? Aesthetics of particular peoples are examined by focusing on subject, style, medium, material, rendering, and what are known as "formal" issues, such as the use of color, line, composition, space, and texture, each of which is discussed here, along with terms that relate to them.

Context

The social or historical situation in which something happens. All artists work in a world of values and conventions to which they respond. For example, some ethnically based artists adhere to time-honored **traditions**, having no interest in innovations and self-expression; their goal is to make things their community wants and needs. A **contemporary** artist, on the other hand, might celebrate individuality, questioning, and change and work somewhat separately from any larger community. This artist might make a point of being uninhibited and breaking "rules." In both cases, we have only to look at the environments in which these differing attitudes exist to see why artists do what they do.

It is important to think about context when it comes to art for at least three reasons. The first is that art provides some insight into the person or culture making it ("the original context"); for example, we can learn something about the Middle Ages from looking at a **medieval** painting. Second, we have to realize that what we see and learn is biased by our own times, experiences, and beliefs; what we understand about the Middle Ages might not be exactly what was understood then. The third is that its immediate context tends to govern what we think about an artwork; seen in a book about knights and warfare, the medieval painting may take on a context additional to the one imparted when seen in the church in Europe for which it was made, or in a museum in our hometown.

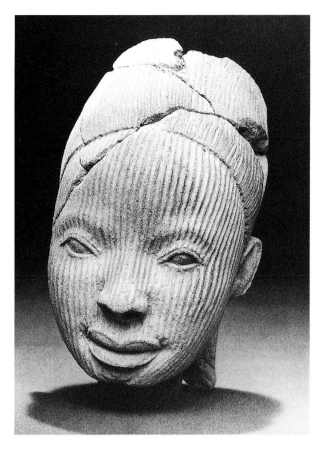

Female head. Ugba Laja, Owo, Nigeria. Yoruba, 15th century. Terra-cotta, height 6⁷⁄₈″. Nigeria National Museum, Lagos

Right:
Aphrodite, from Melos. 2nd century BCE. Marble, height 6′10″. Musée du Louvre, Paris

*These renderings of a Yoruba woman and Aphrodite, the Greek goddess of love and beauty (the Romans called her Venus), are an example of the attempt to **idealize**—to create perfect beauty. They also are an illustration of how **aesthetics** are variable; beauty in one culture is not necessarily the same in another.*

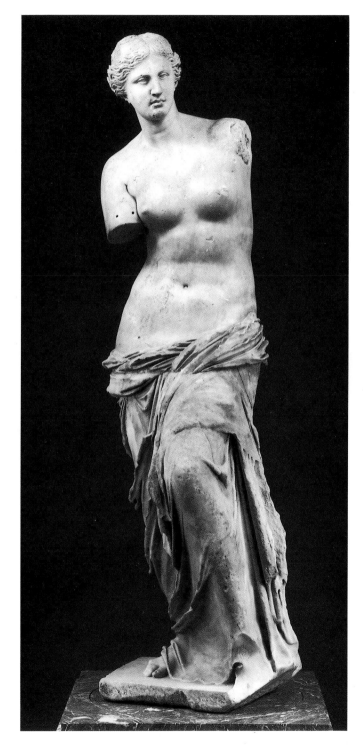

Culture

Describes the human-made world—what it looks and sounds like, what people surround themselves with, what they believe, and what they value. Culture includes more than just the arts. It ranges from aspects of everyday life—clothes and entertainments, for example—to value systems, moral behavior and religious beliefs. A nation, an ethnic group, a religious community, even if it is spread out, can have a culture of its own. Two cultures might share concerns and yet express them differently.

Through much of history, people lived in small units generally contained within certain bounded territories, linked by language, customs, beliefs, mores, myths, and religion: distinct and complete cultures. Because of time and circumstances—conquest, trading, migrating to find a better life or for some sort of freedom, new communication systems, and even intermarriage—these distinct cultures have become rarer. We still have ethnic groups, though many of them are huge and often spread out. We also have traditional cultures; some remain fiercely independent, but others are interwoven or amalgamated, and wholly new hybrids develop as well. There are cultures within cultures: one can be American and still maintain aspects of a traditional ethnic culture. We witness two world cultures, one closely interconnected and one with pockets of ethnic or religious separatism. Occasionally cultures clash: what one group thinks is wicked is appropriate behavior in another. What is a reasonable part of street culture is out of place in a church, temple, or museum.

Idealize

Attempting to create perfection. For example, artists have aspired to fashion perfect ("ideal") human **figures** in order to represent gods, as the ancient **Greeks** and **Romans** did.

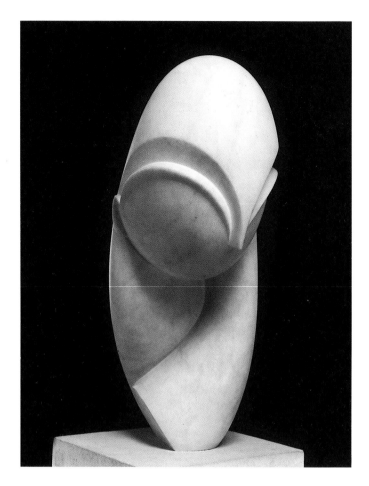

Constantin Brancusi (French, b. Romania, 1876–1957). *Mademoiselle Pogany III.* 1930. Marble, height 17³/₄". Philadelphia Museum of Art. The Louise and Walter Arensberg Collection

Opposite:
Nkondi Nkisi. Bas-Zaire. Kongo, acquired 1907. Wood with iron nails, blades, screws, glass, seashell, height 44¹/₂". The Field Museum of Natural History, Chicago

*In making his portrait of Mademoiselle Pogany, the sculptor Brancusi reduced her features to generalized shapes, thus **stylizing** the representation almost to the point of abstraction. The nkondi, a symbolic figure once used to settle disagreements among the Kongo people, is stylized in another way: its overlong torso, short legs, and small head are "styled" according to conventions that generalize on nature.*

10

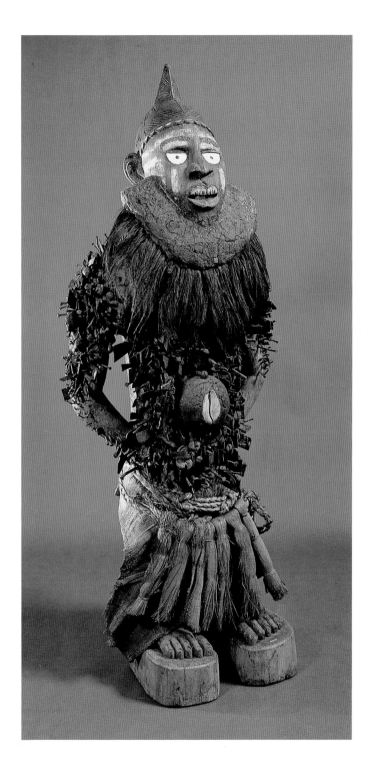

Image

Usually the word is used to mean "picture"—what is depicted. The term "imagery" can be applied also to **abstract** art in order to imply that the colors, shapes, or brushstrokes can convey meanings just as objects can.

Stylize

The act of eliminating or exaggerating details in order to portray a **subject** based on a stylistic pattern rather than nature. For example, an artist may stylize a model's face and body by eliminating all specifics of personality and character. Similarly, **African** or **Oceanic** masks often stylize faces, using pared-down features such as slits for eyes.

Tradition

Refers to a long history of doing something the same way. Traditional art is time-tested, made according to customs and conventions that dictate **style**, **subject** matter, **materials**, and technique. Examples include art specific to an ethnic group, including **folk** art and some aspects of the **crafts**.

Making Comparisons

We can learn a great deal from examining more than one work at a time, looking back and forth to compare one artwork with another. Simply ask the questions, How is this picture similar to that? How is it different? It is perhaps easiest to focus on just one aspect at a time, looking to see, for example, how **subjects** are presented, or how color is used. Among the specifics we can pinpoint by doing this are

 —*cultural differences*. For example, consider two **portraits** of rulers. In one, we might observe realistic description; in the other, individual characteristics and imperfections might be altered in order

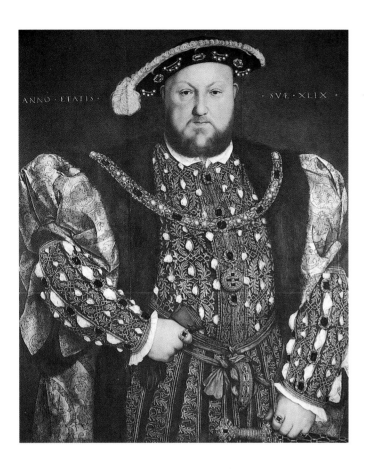

Hans Holbein the Younger (German, 1497–1543). *Henry VIII*. 1540. Oil on panel, 32½ x 29″. National Gallery, Rome

Below:
Jacques-Louis David (French, 1748–1825). *Bonaparte Crossing the Saint-Bernard*. 1800–!801. Oil on canvas, 8'10⅝″ x 7'7¼″. Musée National du Château de Malmaison, Rueil-Malmaison

What different aspects of leadership can we see emphasized by these two views of royal figures? Holbein concentrated on the imposing bulk, costly clothes and jewelry, as well as the sharply intelligent eyes and stern set of the mouth, to produce a close-in portrait of the English king Henry VIII. By contrast, David portrayed Napoléon Bonaparte as a smartly uniformed officer on a rearing steed, clearly ready to move onward and upward, as his pointing finger indicates.

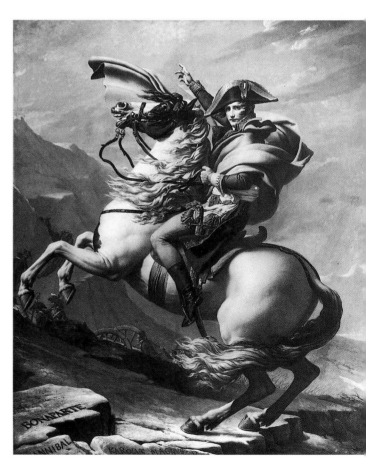

to **idealize** the ruler. In this case, one might or might not recognize His Highness but would think about him as representing a dynamic, maybe even godlike, leader. If we dig deeper into both images, we might be able to surmise two distinct concepts of leadership, power, and faith in rulers.

—*personal feelings of an artist.* In cultures where art is not dictated by tradition and convention, artists may express their own emotions and attitudes through their work. See **expressionism,** for example, or **Mannerism.**

—*judgments of preference or quality.* We can use comparing as a tool for helping us to decide, not just what we prefer, but also what is "good art" and what is not. An essential element in making reasonable assessments of value is having seen enough different things to be able to decide among them which is the best. If you want to pick a favorite self-portrait by the Dutch artist Rembrandt, you have to see all of them. Otherwise you have an incomplete basis for deciding.

Why Do People Make Art?

For as long as we have any record, people have used images to aid in understanding things difficult to express in words. From art, a child in an earlier time might have begun to understand what spirit is or where people go when they die. Stained-glass windows in churches told religious stories containing necessary wisdom and giving instruction to people who could not read. The quiet calmness of a statue of the Buddha provided an example of a way of being. The values, mores, and myths of a culture were taught and reinforced through art.

Artworks, like stories with a moral at the end, often contain or embody **symbols,** representations that stand for other things. Pyramids are not just fascinating structures but also remarkable proofs of human ability, faith, and belief in life after death.

Intricately worked gold, set with precious gems, fills us with admiration for its beauty and also proclaims its owner's wealth. A courthouse with large columns and impressive stairways is not just another building: it is designed to make us feel properly respectful as we enter it.

Art often makes the kind of impression we do not soon forget. A queen might want all to know and honor her and thus commission impressive portraits that give us not only a record of her likeness but also a sense of the power accorded her position. Political candidates use media "portraits" to convince us of their merits as leaders. But while most campaign ads are filed and forgotten, art finds its way into museums because it continues to interest us. Therein lies a key to art: something we come back to, time and again, for pleasure and information.

The best way to approach any work of art is to examine it. If we look, then look again, and think about what we see, we find that most pictures tell us something. Even if at first glance they are hard to interpret, their content usually relates to our experiences, at least to some degree.

Examination leads us to consider what it is artists intend for us to discover. They make choices of what to show—their subjects—and they choose to show their subjects in certain ways. By sifting through *what* artists present as well as *how* they present it, we uncover clues as to their intentions. By weighing various possibilities, we can reasonably deduce some of what an artist wants us to think. And by the way, reasonable conclusions are often the closest we get to the truth. In many cases, there are no absolutely "right answers."

However, even though our eyes can scout clues that convince us of certain things, we have to respect that what we learn by looking may *not* be all there is to know. In fact, it usually is not. Therefore, we may want to learn more. Think of it this way: one not taught about Christianity might believe the Holy Family to be pleasant-looking

Andy Warhol (American, 1928–1987).
Gold Marilyn Monroe. 1962.
Synthetic polymer paint,
silkscreened, and oil on canvas,
6′11¼″ x 4′9″. The Museum of
Modern Art, New York. Gift of Philip
Johnson

*The movie star is a creature unique to
this century. Photography made the
phenomenon possible, but artists in
many mediums have made reference to
it, in each case displaying an attitude
toward the subject. Comparisons make
the differences clear. Warhol seems to
focus on Marilyn Monroe's status as an
icon, a figure adored and endowed with
special radiance. Unlike the rest of
us mortals, she is special and apart, a
bodiless mask isolated in a field of
gold.*

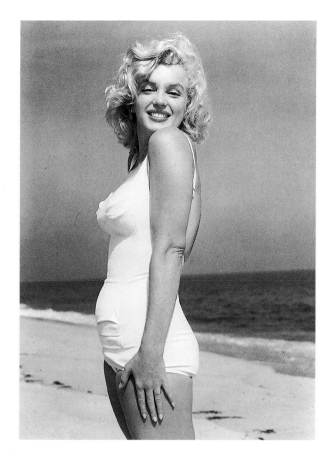

Sam Shaw (American, b. 1912). *Marilyn Monroe.* 1957.
Photograph

*Here we see Monroe, a glamorous and shapely female, posing
for photographer Sam Shaw. Because she is seen close up,
smiling broadly and staring into the camera—and therefore
at us—she seems human, a beauty queen yet somehow not
distant.*

Right:
Willem de Kooning (American, b. The Netherlands, 1904).
Marilyn Monroe. 1954. Oil on canvas, 50 x 30″. Collection
Neuberger Museum of Art, Purchase College, State
University of New York. Gift of Roy R. Neuberger

*De Kooning's "Marilyn" is painted in his semiabstract
expressionistic style. He makes no attempt to create a like-
ness but turns the icon into a beast. Her broad smile is more
a gash than a grin. Her renowned sensuousness becomes
garish excess.*

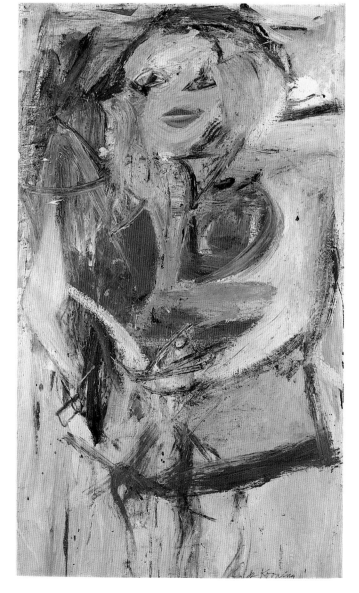

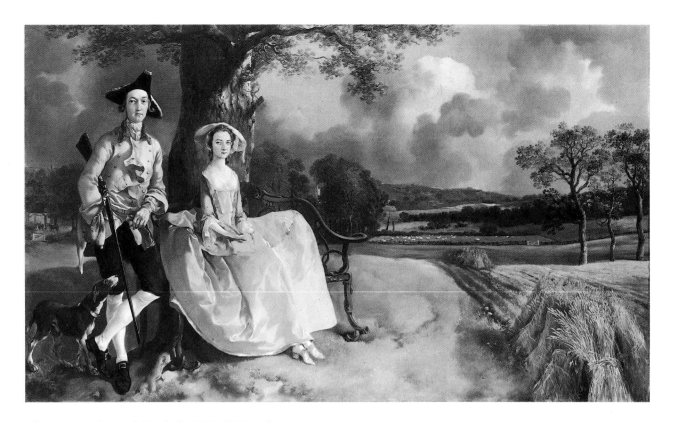

Thomas Gainsborough (English, 1727–1788). *Robert Andrews and His Wife*. c. 1749. Oil on canvas, 27$\frac{1}{2}$ x 47″. National Gallery, London

What can we learn from thinking about this painting? For example, what is the subject? Gainsborough apparently wants us to take notice of a finely dressed couple and their dog. But why did he put them off to the side? By sidelining the figures, the artist seems to make landscape an equal issue. He might be depicting beauty in many forms; his subject could also be relationships—the man and the woman, the man and his dog, the couple and their property. Could he be making any kind of comment on ownership? What other possibilities exist?

Opposite:
Siva Nataraja (Lord of the Dance). India. Chola period, 11th century. Bronze, height 43$\frac{7}{8}$″. © The Cleveland Museum of Art, 1994, Purchase from the J. H. Wade Fund, 30.331

*It is justified to conclude certain things about this figure by studying it—its facial characteristics seem Asian, for example; the body is male and he seems to be dancing; the crown and jewelry might indicate his importance. But there is a limit to what we should assume without further information—such as, Why four arms? Why the circle of what seem to be flames? Acknowledging what we do not know is important in learning from art. Once you discover that Siva is a Hindu deity, for example, you have begun to place the figure in a **context**, enabling you to explore further.*

country folk. Only through investigation will one come to know their second and sacred identity. This is true for most art tied closely to a people or their beliefs, and therefore deep understandings come from seeking more than meets the eye.

One of the ways to get more information about an artwork is to consider what is told in the label that usually accompanies it. Another is to consult books that recount art history. Yet another is to study other kinds of reference tools that provide data about a people, their times, places, and customs. This book provides basic definitions and explanations for getting started, but such information is only a *guide* to looking, not an alternative. Most important to the understanding and enjoyment of art is looking and thinking—and examining our own responses to what we see.

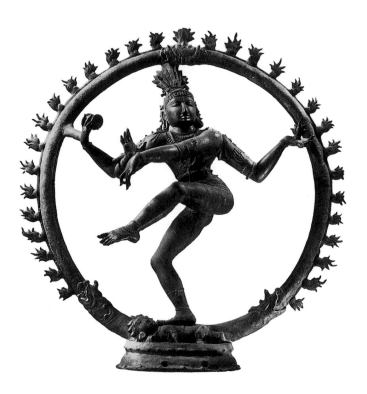

Using Museum Labels

Objects in museums usually have labels nearby, the purpose of which is to help the viewer identify a work. Although they vary in content—some having explanatory texts—most labels contain some or all of the following information:

NAME OF THE ARTIST, when it is known. Many names have been lost to history, in which case "anonymous" or "anon" is often given. When there is some reason to question an identification (for example, no historical records exist to support it), the qualifier "attributed to . . ." will be applied by careful historians. If even less sure, "**school** of . . ." or "studio of . . ." might be used.

NATIONALITY, usually the country of the artist's birth. In the case of artists who were born one place but lived most of their productive lives in another, the "adoptive" country may be given.

BIRTH and, if applicable, *DEATH DATES* of the artist.

TITLE OF THE WORK, often given by the artist. Titles are sometimes descriptions of the work—*Still Life* or *Street, Dresden,* for example. At other times titles are a key to what the artist might want us to think or see—as with *Improvisation* or *The Persistence of Memory.* "Untitled" usually means that the artist has said all he or she wishes by creating the work. The viewer is left to consider meaning based on what he or she sees.

DATE THE WORK WAS MADE OR COMPLETED. Sometimes continuing dates (1965–69) are indicated if the work was completed over a period of time or if the date is not known precisely. The letter "c." for circa ("about") can also be given when an exact date is not known.

MEDIUM AND DIMENSIONS, the materials and techniques used in making an artwork, as well as its approximate size.

ACCESSION INFORMATION AND/OR COLLECTION CREDITS are provided by museums to indicate the manner in which a work came into the collection and as a way of acknowledging donors or lenders.

Times, Places, Peoples, and Styles

Most art is placed in some kind of grouping of similar things. Historically, the most helpful groupings for studying art fall into several broad categories:

the *time* ("era," or **period**) in which something was made, such as **medieval** or **Pre-Columbian** art;

the *place* (part of the world) from which it comes, such as **Asian** art;

the *people* who made it—an ethnic or religious group, or a royal dynasty, such as the art of the Benin people in **Africa**, of **Islam**, or of the **Han** dynasty in China;

its *style*, such as **Gothic** art, in which **architecture**, sculpture, furniture, and even **decorative** objects share visual characteristics.

Eras almost always have hazy beginnings and endings. They often overlap one another, too. As one gradually ends, another begins, and while the styles associated with an era finish in one place, they may still be going strong in another.

Geographical categories are not very exact either, encompassing too much to be precise and not describing in any detail what they refer to. Art of specific regions may share some qualities—for example, the use of similar materials, maybe those that are available locally; methods of making things, such as **carving** in wood or stone or **bronze casting**; and function, such as making objects for worship or ceremony. There are, however, many differences, too, and as with all categories, geographical ones only establish a direction for our thinking.

A style usually develops alongside other aspects of a culture. For example, the religion of a particular people will contain a view of its gods and/or goddesses; the style developed to represent divine figures will grow out of this view. The ancient **Greeks'** gods and goddesses bore many human characteristics, and as a result, they were represented in art as **idealized** humans, more perfect than we expect people to be. In some cultures, such as that of the Pre-Columbian Aztecs, gods share characteristics with animals and humans, and their depictions require a more imaginative style.

The term "style" should not be confused with "fashion" or "fad," which usually involves a style but tends to pass quickly. Artistic styles can endure for centuries, although in modern times, shifts from one to another take place frequently. At this point a style might last a decade or two and, occasionally, only a few years.

Keep in mind that many stylistic terms have been coined by art historians working in Europe and the United States, for the most part, and therefore reflect their sense of the world. Seldom have they come from artists, except unwittingly. The term **Impressionism** was borrowed by a critic from the painter Claude Monet, who called an early painting *Impression, Sunrise*. The critic disliked the picture and chose to make fun of it by focusing on the word "impression," which to him meant something insubstantial and unworthy of the great art of painting.

At present many terms that we use to help us sort out objects of one kind and another were not applied in the object's original culture. For example, in the European Middle Ages, artists made objects whose uses were closely linked to their religions and ways of understanding life. They were not sculpture in the modern sense of the word—meaning a three-dimensional object, usually decorative to some degree. Distinguishing between a twentieth-century **Western** point of view and that of other times and places is an important trend in recent cultural studies.

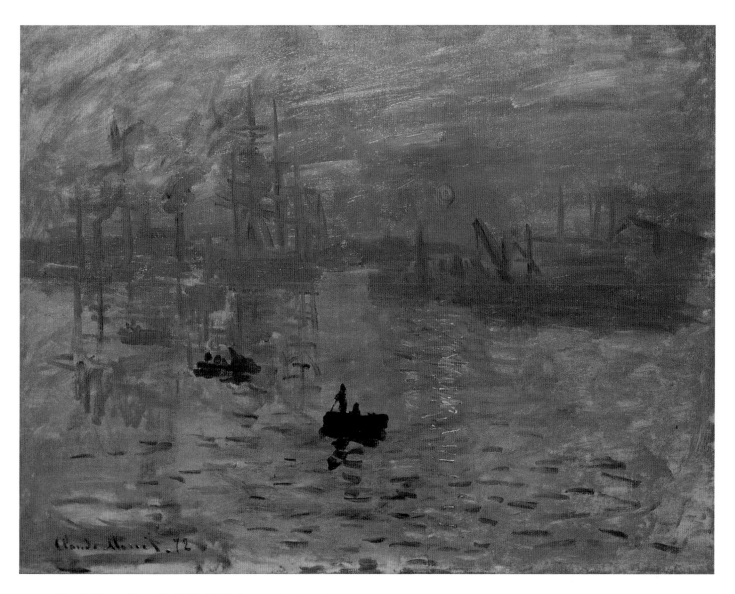

Claude Monet (French, 1840–1926). *Impression, Sunrise.*
1873. Oil on canvas, 17³/₄ x 21³/₄". Musée Marmottan,
Paris

*This painting's title gave a name to the **Impressionist** move-
ment, which is appreciated a great deal more now than when
it happened (see also p. 49). Monet's concern seems to be the
capturing of a passing moment in the early morning light.*

Aboriginal

Can refer to any art that is native to an area or ethnic group, especially as a means of distinguishing the earliest art of a region from what developed later. It is often used specifically to refer to art of the original inhabitants of Australia (see illustration at right).

Abstraction

Applies to art that looks as if it contains no recognizable **forms** from the physical world. All the artist gives us to focus on are **colors**, **lines**, **shapes**, and **materials**. We can find abstraction in periods, places, and styles throughout history, from **Islamic patterns** to **modern painting**.

Most art is abstract to some degree: a painting is only a *picture* of something, never the real thing, even if it is presented very realistically. Artists often "abstract" the objects or people they represent by changing, simplifying, or exaggerating what they see. A mask maker who reduces eyes to circles or slits is abstracting from nature.

Some completely abstract art is based on geometry—squares, for example, or forms that appear to have **volume**, such as cubes or pyramids. Other abstractions are free flowing and irregular. "Lyrical" is one word applied to the latter; "organic" is another. The shapes we see in these may suggest things we recognize—figures, for example—and sometimes the artist actually wants us to find them. Usually, however, no specific allusions to the "real world" are intended.

In one sense you can say that the **subject** of abstract art cannot be pinned down. It can be anything you can make of it: in some cases, we find images such as those we see in cloud formations, or an evocation of mood or atmosphere. Most often, abstract art is about patterns, or how different colors and shapes relate to each other, or impressions. For example, very careful painting can give one impression, while quick, fast **brushstrokes** can convey quite another.

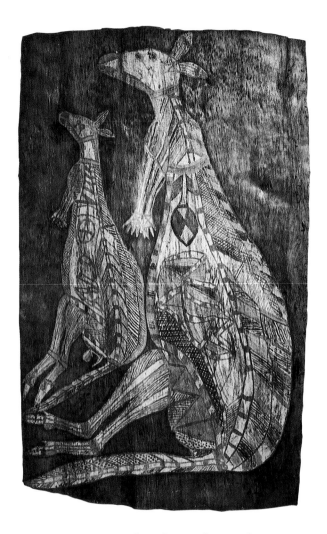

Two Kangaroos. Australian aboriginal, 19–20th century. Painted bark, 40³/₄ x 25″. The Metropolitan Museum of Art, New York. The Michael C. Rockefeller Memorial Collection, Bequest of Nelson A. Rockefeller, 1979 (1979.206.1514)

Opposite:
Vasily Kandinsky (Russian, 1866–1944). *Improvisation 31 (Sea Battle).* 1913. Oil on linen, 57¹/₈ x 47¹/₈″. National Gallery of Art, Washington, D.C. Ailsa Mellon Bruce Fund

*Kandinsky used visual imagery to embody sounds as well as spiritual concepts. He titled many of his **abstract** paintings with names that refer to musical composition, supposedly visual counterparts to musical forms.*

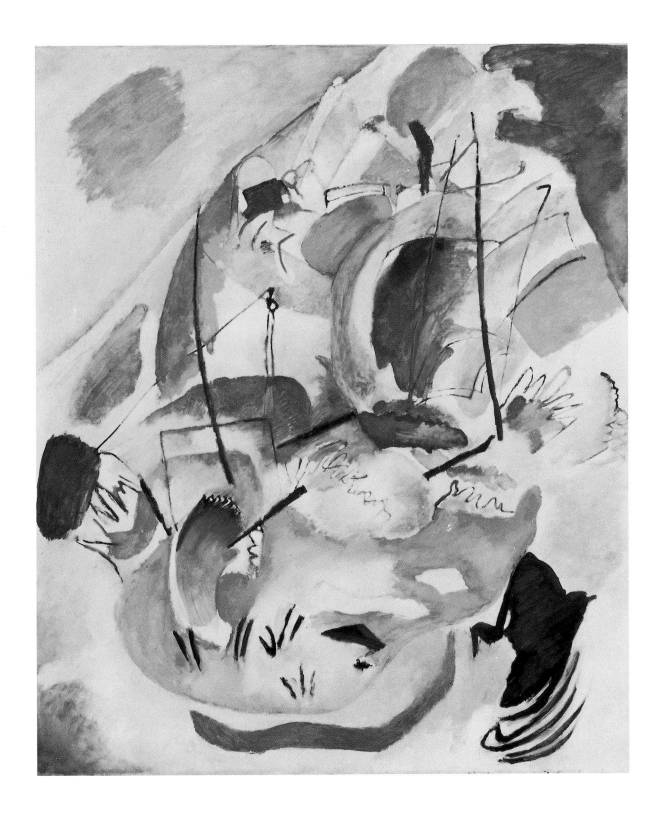

Two other words, whose meanings are slightly different, are sometimes substituted for "abstract." "Nonobjective" is used to describe work that contains no references to objects from the physical world. "Nonrepresentational" refers to an artwork in which the artist has no intention of symbolizing or evoking reference to anything outside itself.

African

Refers to art from the continent of Africa, including **Egyptian**, Nubian, and Ethiopian art and the **Islamic** art of North Africa, each of which has had a significant impact on the art of other **cultures**. Add to this the many ethnic groups living below the Sahara Desert, and one can see that the term encompasses a huge variety of cultures, whose richness is done little justice by this general category.

Much art from sub-Saharan Africa—objects of **carved** wood, **costumes**, dances, music, jewelry, and body decoration, even oral literature—has disappeared over time, leaving historians and archaeologists with few clues to what the history of the art and culture has been. Most of what we know dates from the beginnings of Africa's colonization, and much has been filtered by the values of the non-Africans who have reconstructed it.

Different language and ethnic groups have created art incorporating tremendous variations dependant on climate, resources, and habits—such as whether or not a people were nomadic. Until recently, there was generally no distinction between art and **craft**, and **form** followed function: what an object represented or what it was used for dictated its appearance; techniques were based on **tradition**, not invention; and quality was measured according to custom. Most art was made from **materials** at hand, especially wood, with additions—for example, shells or certain kinds of beads and metals—often acquired through trading. Each different pose or attitude—standing, sitting, riding, kneeling, supporting, and balancing—carried **symbolic** meaning, and combinations, e.g., kneeling with hands behind

the back, might mean something else again. Certain cultures (such as that of the Bamana) featured associations—or "guilds"—each of which had its own mask and ritual. A few of the many sub-Saharan ethnic groups whose art is widely appreciated in **Western** culture are listed below. (See also illustrations, pp. 10, 124, 147.)

The *Ashanti* people of the Ivory Coast are known for their terra-cotta **portraits** intended to represent specific religious or noble **figures**. Because their features are highly **stylized**, the **subjects** are identified by specific accessories—such as hairstyles and jewelry. By the eleventh century the Ashanti were very skilled in the use of metals, with which they created many different objects, notably small, very complex **cast**-gold jewelry and figures used as weights. Some of the design shows the influence of Islam. Most Ashanti art represents some historical event of importance to their religion or folklore.

The *Bamana* of West Mali are known especially for their wooden headdresses or crowns in the form of antelope heads. Also distinctive are their large and naturalistic figures relating to maternity, as well as smaller statues of women, simplified to the kind of geometry appreciated by **modern sculptors**, most having exaggerated feminine attributes. Bamana objects and masks are often connected to initiation and other events involving the gaining of knowledge and status, and often they indicate the rites of a particular association, such as that of blacksmiths.

Once called the Dahomey, now the People's Republic of Benin, the *Benin* culture reached a point of great sophistication in the sixteenth and seventeenth centuries. The Benin tradition of working in **bronze** has meant that the art of earlier times is relatively abundant. Some Benin art, such as the heads of royal figures, is free standing. A frequent art form is the plaque, sculpted in **relief**. Even in portraiture, Benin art tends to **stylize** features and to simplify and generalize physical attributes. The

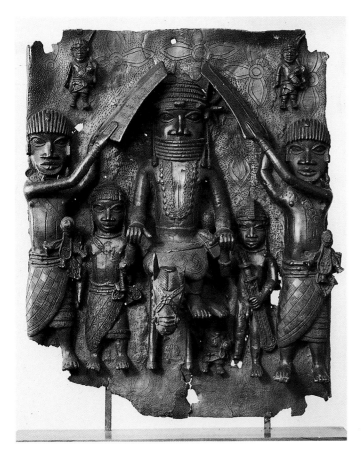

King Mounted, with Attendants. Nigeria. Court of Benin, 1550–1680. Bronze, 19½ x 16½". The Metropolitan Museum of Art, New York. The Michael C. Rockefeller Memorial Collection, Gift of Nelson A. Rockefeller, 1965 (1978.412.309)

scale of figures—their size compared to others in a work—usually indicates their social position, with kings represented as largest. The elaborateness of jewelry and other apparel indicates wealth and status, as it does with many African cultures.

From the border region between the Ivory Coast and Liberia, the *Dan* people are known for masks, their principal form of sculpture. The eyes of the masks, of varying shapes, often signal the mask's function. Worn with costumes in rituals, the masks do not simply represent great spiritual power but also embody it. The Dan are also noted for making wooden spoons with handles carved into shapes representing qualities to which one might aspire, indicators of the generosity and hospitality of the women to whom they were given.

The *Dogon* of southern Mali are characterized by a wide range of objects having to do with their religion and values, often representing creation stories and fertility. Sculpture, including masks that represent certain animals, are used in ritual ceremonies in which ideals and important knowledge are passed on to the young. Dogon figures tend to be elongated and stylized, and some objects, such as doors, feature repeated figures, some containing both male and female characteristics. Other objects have interlocking parts. Dogon metalsmiths and woodcarvers belong to a special "caste," or position in the social hierarchy.

Important to the *Luba* culture of the southeast Congo region are stools supported by slender, elegant figures who symbolically "carry" the power of the ruler. In the carving of other figures, mostly female spirits, great attention is paid to details such as the pattern of hair or of body decoration. Wooden surfaces are smoothly carved and polished to a dark sheen.

The *Masai* are a nomadic people living in East Africa, primarily in Kenya and Tanzania. Most are herders who continue to live off the meat, blood, and milk of their livestock. Typical of nomadic peoples—of which there once were many in Africa—the

From left to right:
Headrest with supporting figure of kneeling woman with hands to trunk. Zaire. Luba, n.d. Carved wood, 6 x 3 x 3¾." Private collection

Ancestor figures. Mali. Dogon, n.d. Carved wood, height 24⅝." Reitberg Museum, Zurich. Von der Heydt Collection

Olowe (Nigerian, d. 1938). Door from the royal palace of Ikerre, Nigeria. Yoruba, c. 1910–14. Carved wood, height 7'. British Museum, London

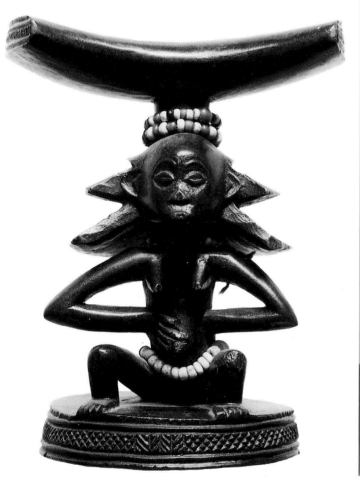

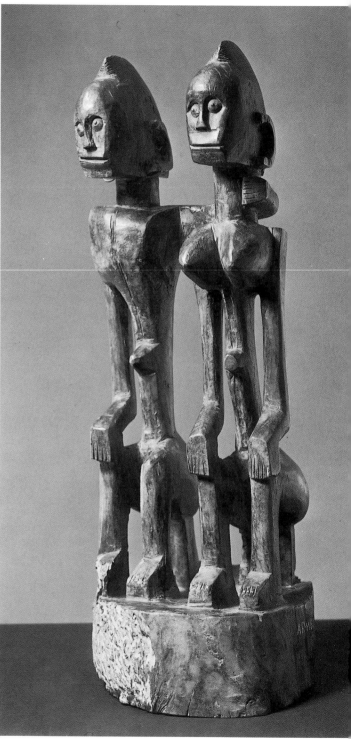

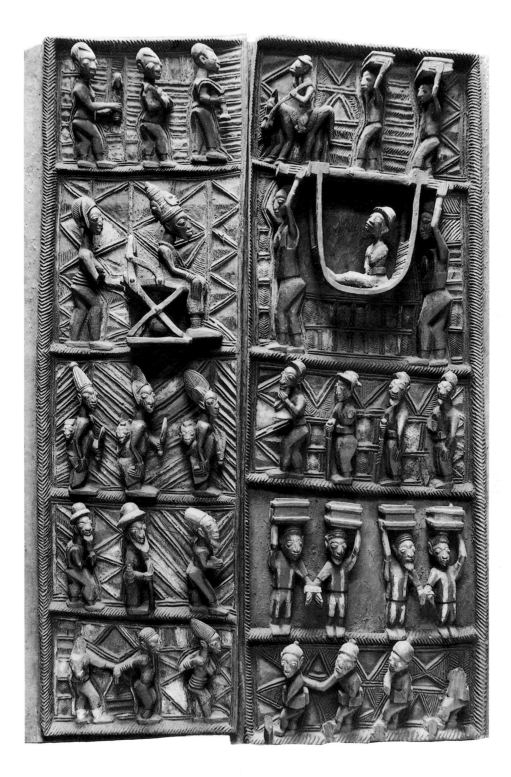

Masai carry with them all that is essential. Therefore, their art consists not of sculpture but of portable leather and woven objects, beadwork and jewelry, ritual body decoration, as well as a rich culture of music, myth, dance, and ceremony.

The Neolithic *Nok* Kingdom of Nigeria produced **ceramic** sculptures that can be reliably dated to 500–200 BCE, the earliest evidence of art in sub-Saharan Africa. The degree of expertise indicates the earlier presence of object-producing cultures in the area. Among the excavated objects are terra-cotta heads, most of them animated and recognizably human yet stylized, and it would appear they were once attached to bodies.

Some of the best known art of the sophisticated *Yoruba* people of southern Nigeria is associated with the religious center in the holy city of Ile-Ife, which flourished from the eleventh to fifteenth century, before the presence of Europeans. Bronze heads, **cast** by the "lost-wax" method, and terra-cotta figures are thought to have been made in an effort to sustain the power of a dead king. While stylized, with serene yet powerful expressions, the faces contain some sense of specific personalities.

American

Usually refers to art created in North America beginning when it was a set of European colonies and sometimes including the art of Canada, Mexico, and of American Indians. Some "American" art is made by artists who live in New York City and paint huge **abstractions**. Some is stitched by people at home according to traditional **patterns**. There is "American" **naive** art made by people with no training but a great deal of feeling and a unique vision. And so on. As we view the vast array of art produced in the United States today, we realize that it is difficult, if not impossible, to pin down a specifically "American" identity.

The story of American art is complicated partly because we are a nation of many cultures. American Indians, or **Native Americans**, and their many cultures produced and used objects now collected as art, most appropriately identified by the names of different ethnic peoples, such as the Hopi or Iroquois. Their designs, materials, and architecture take many forms today, some of them distinctly part of individual tribal cultures and others reflective of diverse sources coming together in North America.

The Europeans who colonized the **Western** Hemisphere brought their arts with them, which they continued to practice. For many generations these and other immigrant groups looked back to the "old countries" to inspire any changes that occurred. Some of their ideas and ways eventually interwove with others. In any case, much of what we call American art has roots elsewhere.

African people also brought with them ideas and customs that, no matter how much they were suppressed, continued to influence the practice of people's lives. Their impact on the American arts is profound and often not recognized.

Ancient

In art, the term usually refers to **cultures** that existed when history began to be recorded as it is today. Ancient art extends as far back as the Paleolithic **period** (or "Old Stone Age," which began approximately 2 million years ago and ended c. 10,000 BCE), from which cave **paintings** and small **carvings** in bone, horn, and stone have been found throughout western Europe, the earliest dating from around 30,000 BCE. The Neolithic period (the "New Stone Age," c. 8000–3500 BCE in eastern Europe and much of **Asia**; 8000–1500 BCE in the Americas) saw the development of societies living in settled communities, domesticating animals, and cultivating crops. More plentiful in museums are artifacts from the "Bronze Age" (c. 3500–1000 BCE) cultures of Mesopotamia—the Sumerians, Assyrians, and Babylonians, for example—as well as those of the Aegean Sea region—the Minoans and the Mycenae-

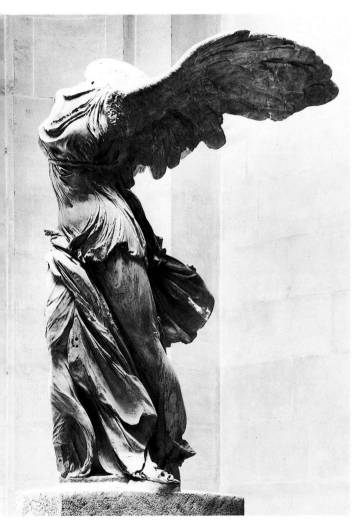

Winged Victory (Nike of Samothrace). c. 190 BCE. Marble, height 8′. Musée du Louvre, Paris

This **ancient** sculpture portrays the Greek goddess Athena with wings, striding forward to commemorate victory. She is clearly strong and powerful. Her sense of forward motion comes not only from her position but also the furling of her robes, showing a naturalism typical of Hellenistic art.

ans—from which eventually developed the art of **classical Greece**, with its high point in the fifth century BCE. Also included within the category of ancient are the cultures of the early **Egyptians**, **Romans**, and even that of the **Pre-Columbian** Maya.

We often use the process of "archaeology" (digging into the ground to see what has been covered over) to find evidence of past cultures. We then examine the unearthed art and artifacts, including any **decoration**, writing, and **symbols**, to decipher the stories of a people and their ways of life and death. Art is thus an essential tool for constructing what we know of the past.

Like geographical terms such as **American** art, the word "ancient" is vague in meaning. As with the word "antique," ancient mostly refers to things that are old. And, we have to think, old compared to what? In the United States, we often view hundred-year-old objects as antiques, and they are, compared to the short history of this nation. But to **Native Americans**, who trace their roots further back in time on this continent, a hundred years may not seem long at all.

Art Deco, or Moderne

Style in **decorative arts** and **architecture** popular in the 1920s and 1930s, mostly in Europe and the United States. Its goal was to adapt design to the technologies of mass production and to the availability of new materials. We find Art Deco buildings throughout the industrialized world, which can be seen as a measure of the degree to which a global culture was beginning to develop.

Art Deco can be identified by its slim geometric, often **symmetrical**, **forms** and **linear patterns**. If the earlier **Art Nouveau** was anchored in nature, sleek Art Deco elegantly celebrated the machine age. People are represented in sculpture as glamorous, powerful, and bold. It is a design reflective of a world optimistic about its future, especially in the advances in speed and convenience made possible by machines and mechanization.

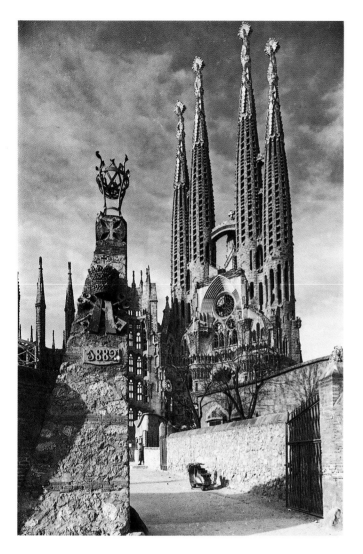

Antoní Gaudí (Spanish, 1852–1926). East facade, Church of the Sagrada Familia, Barcelona, Spain. 1883–1926

Art Nouveau was an enormously fanciful style, and the architect Antoní Gaudí was a master of structures that seem to come out of fairy tales. His not-yet-finished Church of the Sacred Family in Barcelona, his native city, was inspired in part by earlier Gothic churches, as well as by nature.

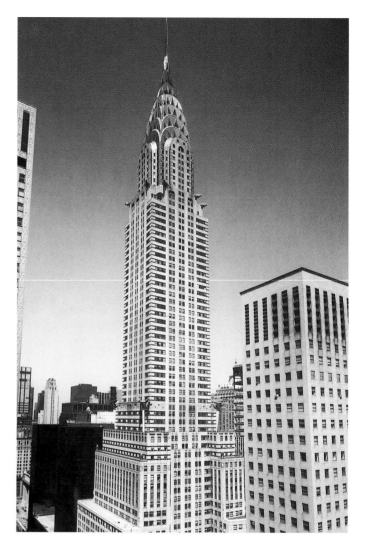

William Van Alen (American, 1882–1944). Chrysler Building, New York City. 1928–30

*The skyscraper is itself a symbol of the modern era. Coupled with the sleek lines, clear patterns, and the dramatic flair of **Art Deco** design, this example—an enduring landmark of the New York skyline—seems to burst upward as a monument to technology. (See also illustration, p. 98.)*

Art Nouveau

Style that broke radically with "revivalist" **traditions**, such as Neo-Gothic, just as the nineteenth century ended and the twentieth began. Art Nouveau designs are dense with swirling **lines** and are usually **asymmetrical**, like nature's irregular **patterns**. They are, in fact, often based on plants, flowers, or other natural forms such as waves of water and the curves of a woman's body or hair. Decorative aspects were integrated with structure, so that a cascading vine of leaves might also be the supporting column of a wrought-iron balcony. The images often seem mysterious or mystical and, in fact, represented a rejection of art-historical styles in order to seek inspiration solely in nature.

Asian

Technically, art from the entire continent of Asia, but usually referring to art from India, China, Korea, Japan, and the Southeast Asian nations, such as Cambodia, Thailand, and Indonesia. The term can encompass art from any time, although museums and books tend to focus more on art of Asia's past than its present.

Very few generalizations carry across the great distances and vastly different peoples of Asia. Among them are that art often has a religious function, **symbolizing** key aspects of the life of **Buddha**, for example, or depicting the gods of the **Hindus**. Asian art also tells stories about life of the people, sometimes whole histories. One frequently finds interest in nature, particularly the human place within it. Skilled craftsmanship, learned usually through extended apprenticeships, is required; most Asian **painting** and **ceramics** exhibit perfection of **forms**, intricate detailing, and controlled **brushstrokes**. In both imagery and **craft**, **tradition** rules, the past is revered, and the creative process of the artist is integral to the work. Some Asian **designs** are simple and spare, and we can be struck by the eloquence of a single **brushstroke**, for example, in the same way we admire haiku poetry. This visual simplicity has had a strong influence on art in Europe and the United States.

Avant-garde

Experimental or daring art, usually of the twentieth century, taken from a French military term meaning the "front line." Unfamiliar and perhaps shocking, avant-garde art is usually considered radical when first introduced to the public, only to be accepted later.

Baroque

The original meaning of Baroque ("irregular, contorted, grotesque") was an uncomplimentary description of a broad style that evolved in Europe in the 1600s. By now the meaning of the word has changed to be descriptive without any negative connotation.

The Baroque style flowered in Europe and Latin America from about 1600 to 1750. In sculpture and architecture, Baroque represents energy and boldness and contains many ornate touches and embellishments. The **paintings** are alive with bright and contrasting **colors**, filled with activity and motion. The artists' command of **illusion** was extensive, and they were particularly intrigued by creating vast **spaces**. They often worked on a grand **scale**, painting on canvases and creating huge wall and ceiling **murals**.

Baroque **subjects** are often dramatic. Artists tried to portray emotional and, to some extent, psychological states—for example, see Rembrandt's **self-portrait**, p. 145—even to relay sexual charge. They painted real people in real situations and their brightness and lively scenarios helped to capture the excitement of a particular moment.

Buddhist

Refers to the ideas of Buddha, a religious teacher who lived in India from around 563 to 483 BCE. Because Buddha's teachings spread, Buddhist art can be found throughout much of Asia.

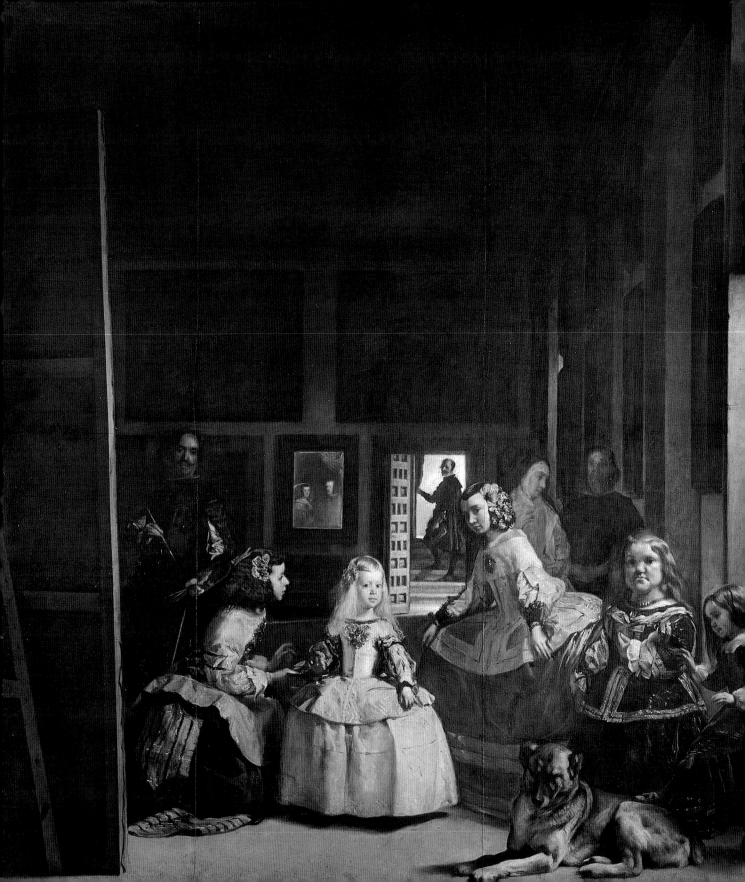

Opposite:
Diego Velázquez (Spanish, 1599–1660). *The Maids of Honor.* 1656. Oil on canvas, 10′5⁷/₁₆″ x 9′¹⁵/₁₆″. The Prado Museum, Madrid

The grandness of the architecture and the rich and varied textures of the materials complement the curious activity of the drama in the foreground of this masterpiece of the **Baroque** *style. Velázquez uses details and figures as well as an intricate pattern of light—issuing from various sources and reflecting off of others—to encourage our eyes to wander through this painting, discovering more and more, wondering why people are there and who means what to whom.*

Madonna and Child on a Curved Throne. 13th century. Tempera on panel, 32¹/₈ x 19³/₈″. National Gallery of Art, Washington, D.C. Andrew W. Mellon Collection. © 1994 Board of Trustees

Typical of **Byzantine** *imagery, this painting conforms to a strict set of compositional rules that lasted centuries. We see the Virgin Mary and Jesus, posed frontally and surrounded by angels in a field of gold. Their faces and bodies are stylized and the rest of their clothing is mostly a pattern of lines. The chair in which they sit also seems more a pattern than a three-dimensional object.*

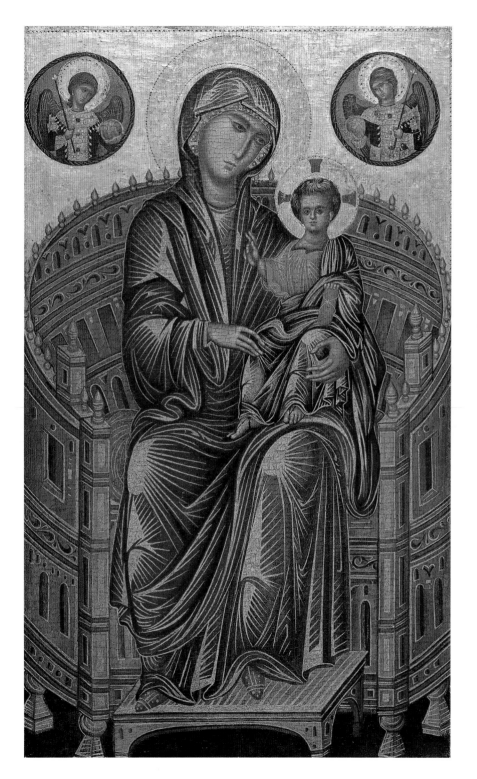

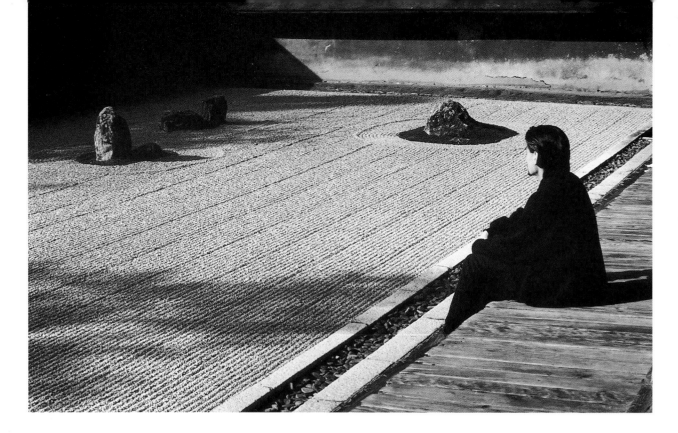

"Dry Landscape." Meditation Garden of Ryoan-ji, Kyoto, Japan. Muromachi period

*Gardens for contemplation are part of the art of Zen, a sect of Mahayana **Buddhism** that developed in Japan. The gardens are usually very simple, consisting of a few natural elements, mostly stones, in a raked field of sand or fine pebbles, with occasional carefully pruned plants. Ordered by intuition, the gardens attempt to achieve a balance between nature and human intervention.*

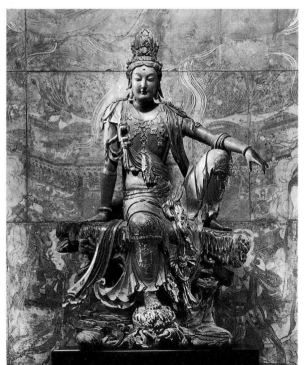

Left:
The Water and Moon Guanyin Bodhisattva. Shanxi Province, China. Northern Song or Liao dynasty, 11–12th century. Painted wood, height 7′11″. Nelson-Atkins Museum of Art, Kansas City, Missouri (Purchase: Nelson Trust) 34-10

*Elegantly regal, this carved figure of a "bodhisattva" (in Mahayana **Buddhism**, an enlightened being) is identified with mercy and gentleness.*

Principles essential to Buddhism are that suffering is to be expected in life and that moral and mental purification is the key to liberation from pain. There are many ways of interpreting the Buddha's ideas, and they result in different strains of Buddhism, many involving reflection (meditation) and quiet. Statues of Buddha are often seated in a pose that suggests contemplation and depicts gestures that carry **symbolic** meaning.

An important **architectural** Buddhist form is the Indian "stupa," a circular mound of earth (perhaps containing relics of the Buddha), faced with carved stone and surrounded by a pathway and a protective wall (often square), with four gates facing north, south, east, and west.

Byzantine

Byzantium was a major crossroads city on the site of what is now Istanbul, Turkey. Constantine, the Roman emperor who made Christianity the empire's official religion, rebuilt the city in 330 CE, renaming it Constantinople and making it his capital. When the Roman Empire split permanently at the end of the fourth century, the eastern portion of it—most of Asia Minor and the Balkan Peninsula—became known as the Byzantine Empire, still governed from Constantinople.

Byzantine art was influenced by elements of **Greek** and **Roman** art (such as an emphasis on **idealizing figures**). It is a style frequently identified with early Christianity, although the latter actually developed in a range of styles in Europe while it remained essentially the same in the East for hundreds of years. Much Byzantine art had to do with praise of God and heavenly order. There was no large-scale sculpture; many objects were small so they could be carried easily for worship; especially prevalent were portable "icons" (from the Greek word meaning "image")—sacred figures, often of the Madonna and Child, painted on small wooden panels. Some Byzantine art depicted no people at all, only **symbols** such as the cross (see p. 97).

Several things stand out in Byzantine art. The backgrounds are usually filled with gold, and other areas are painted with rich **colors**. It contains almost no elements that make you see space or volume. **Lines** are obvious, used to outline figures and **decorative patterns**. If we recognize the figures, it is because of what they hold or how they are posed, not because of any attempt to give them "real" personalities. Important to Byzantine **architecture** was the central-plan church, having four equal arms, its crossing often topped by a dome. (See also p. 103.)

Classical

An imprecise term applied in the **Western** world to the civilizations of **ancient Greece** and **Rome**, which, though different in many ways, are linked in part because of Roman admiration for Greek civilization. Both groups are admired for their political systems, philosophy, history, art, and architecture.

Art historians often use this term to refer to Greek art from roughly 480 to 400 BCE, when Greece was dominated by the city-state of Athens. It is a term of respect for Greek artistic achievement, characterized by **symmetrical**, **harmonious** architecture on a human scale and sculpture whose **idealized** forms seem too good to be true. Although there is evidence that the stone was brightly painted in Greek times, the paint has weathered and marble's pure whiteness fits our concept of the restraint and beauty of classical art.

In popular usage, "classical" refers as much to ideas as to things. Many of the values we honor today—including our sense of what is great in art—were established during these periods. For example, the Greek and Roman concept of respect for individuals is considered the initiation of democracy—equality among citizens, although many people, including women, were not eligible for citizenship. Whenever artists—and government leaders as well—have attempted to revive classical culture, they were trying to identify with harmony, balance, respect for the past, and the notion of striving for perfection.

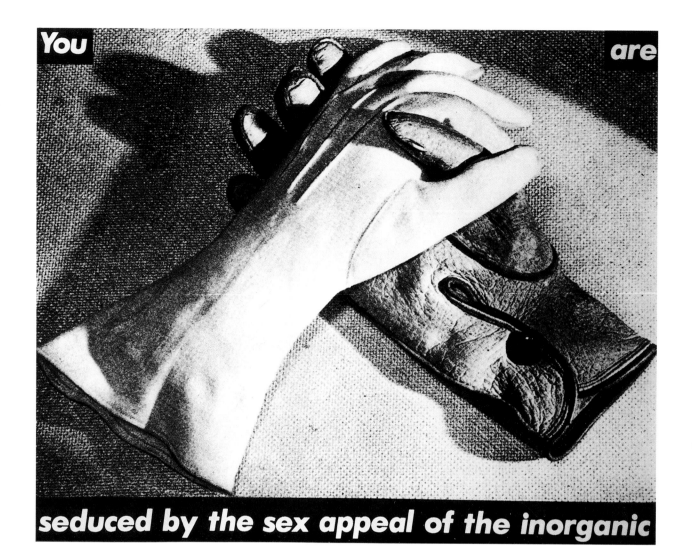

You **are**

seduced by the sex appeal of the inorganic

Barbara Kruger (American, b. 1945). *Untitled (You are seduced by the sex appeal of the inorganic)*. 1981. Photograph, 38 x 50". Collection Hank S. McNeil, Jr., Philadelphia

*Though some **Conceptualists** avoided images altogether, Kruger created artworks by combining text and pictures, usually more complementary than closely related. As objects, they are not precious, but as ideas, they echo in one's memory. Once familiar with Kruger's art, it is hard to see certain styles of type as well as kinds of images and layouts without thinking of her work.*

Conceptual Art

Since the 1960s, a tendency has existed among some **modern** artists to use written text as most (or all) of their art, making it similar to poetry but "framed" as if it were visual art. Conceptual art can use nonart **mediums** and **materials**, such as video, slide projectors, and **photographic** techniques that ignore **aesthetic** considerations. Some visual art has resembled signs or billboards. The name "conceptual" derives from the art's focus on ideas (see also **Dada**). Most of our response to it takes place in our minds, our eyes being taxed very little.

Contemporary

The term that designates art being made today. It is sometimes confused with **modern** art because both sound as if they could refer to "now." In fact, museums make a distinction between the two, tending to define modern art as **styles** that began in the late nineteenth century and, to some extent, carry on to this day. Contemporary art is often seen as a response to modernism, and some of it is dubbed **postmodern** because of the way it rejects the aesthetics and concerns of earlier modern styles.

The most striking aspect of contemporary art is that it is remarkably diverse and fast-changing. Today's artists make a point to keep up with shifts in technologies as well as ideas. They acknowledge that our lives are varied and often changing, and they want to keep pace. Many of them are concerned with social issues and take a critical stance with regard to the way things are. Contemporary artists employ all **mediums**, from paint to clay, photography to video, computers to neon.

Cubism

One of the first radical developments of **modern** art, Cubism is a style of making pictures that tends to **abstract** objects, people, or places. The **subjects** are often incomplete, simplified into geometric **shapes** and **forms**. There is very little indication of **space** in Cubist art. There tend to be few **colors** used, mostly

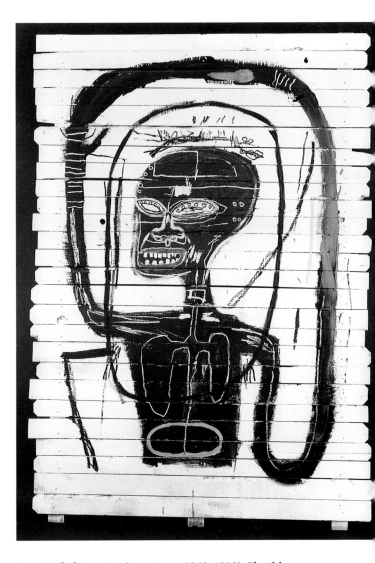

Jean-Michel Basquiat (American, 1960–1988). *Flexible.* 1984. Acrylic and oil-paint stick on wood slats, 8'6" x 6'3". Estate of Jean-Michel Basquiat

*Many **contemporary** artists use recognizable imagery but show little concern for careful craftsmanship. The sources of the images are diverse and often very personal. In Basquiat's case, associations with African art, Mexican folk art, and underground cartoons can be made. Even then, what results is highly individual in style and elusive in meaning.*

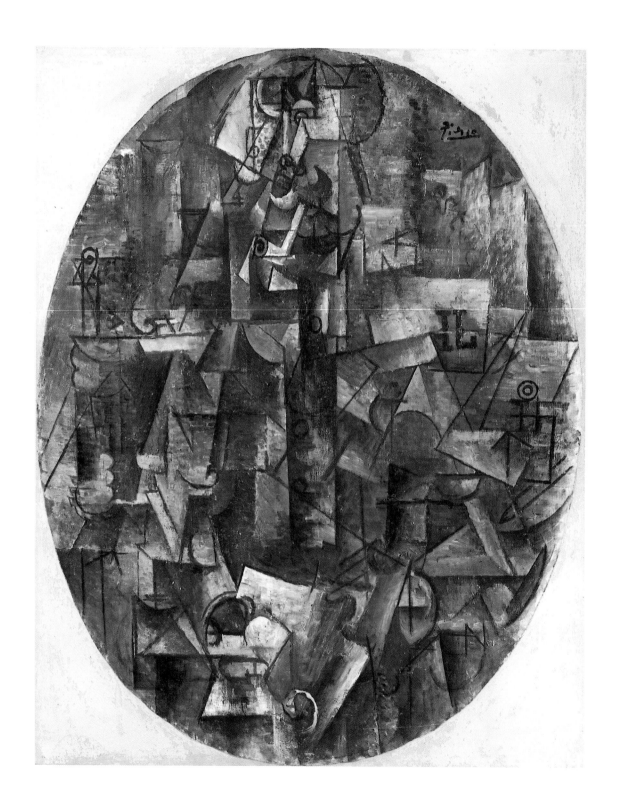

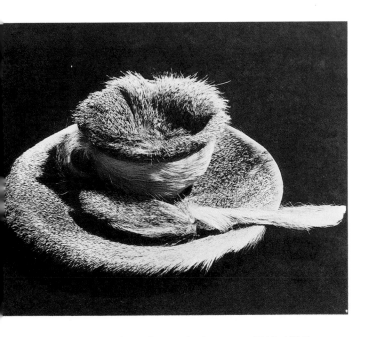

Meret Oppenheim (Swiss, b. Germany, 1913–1985).
Object (Le Déjeuner en fourrure). 1936. Fur-covered cup,
saucer, and spoon; cup diameter 4³/₈″, saucer diameter
9³/₈″, spoon length 8″. The Museum of Modern Art, New
York. Purchase

*Often referred to as the "fur-lined tea cup," this object by
Dada artist Meret Oppenheim reflects the humor and irrever-
ence of this group of artists. Her image is nonsensical;
nonetheless, the artist tempts us to read into it: teacups and
furs can be associated with elegance, or cups and spoons
with female/male symbolism, and so forth.*

Opposite:
Pablo Picasso (French, b. Spain, 1881–1973). *Man with a
Pipe*. 1911. Oil on canvas, 35³/₄ x 27⁷/₈″ (oval). Kimbell Art
Museum, Fort Worth, Texas

*Picasso's **Cubist** "man with a pipe" is a puzzle of flattened
planes and occasional forms—cylinders and cones. There are
just enough details of face, body, and pipe to tempt us to
look for the figure, despite the emphasis on geometry in
space.*

browns, grays, and blacks. Objects represented are
often broken apart and sometimes shown from two
or more sides at once. Looking at them requires
puzzling about what each shape or **line** might
signify.

Cubism was invented just before World War I
by the artists Pablo Picasso and Georges Braque,
who were searching for new means of depicting the
world, not so much from *looking* at it as *thinking*
about it. They realized that they could alter, exag-
gerate, and distort objects at will. It was as if, hav-
ing looked at a subject from many **vantage points**
and then thought about it, they constructed a mem-
ory of the experience.

Dada

A French word for "hobbyhorse," Dada was the
name given to a radical **modern** art movement aris-
ing partly in response to the conditions and behav-
iors that provoked World War I, as well as its
devastating consequences. Angry and upset, a num-
ber of artists found ways of criticizing society
through their art.

Dada artists broke away from all **traditions** and
ridiculed conventional rules. They felt that what
happened around them made no sense, and they
concluded, therefore, that what *would* make sense
was nonsense. For example, if art of satire and
protest was typically painting and drawing, they
would stage events. Since it was customary to craft
art objects out of precious materials, Dada artists
would work by means that were cheap, soon
exhausted, and "uncollectible." They also brought
everyday objects (artist Marcel Duchamp called
them "ready-mades") into galleries, arguing that as
artists they could decide what was art. Moreover,
they declared, the meaning of an object would
change depending on its setting; if a urinal was
placed in an art gallery, then it must be art. Dadaists
argued that creativity is a matter of ideas, not **craft**.
Anyone, they said, could learn to make some-
thing—even a machine—but only really creative

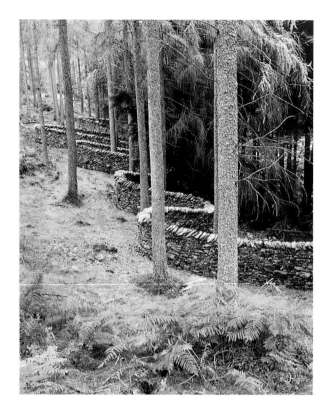

Andy Goldsworthy (English, b. 1956). *Wall that went for a walk*. September 1990. Stonework by Joe Smith, Philip Dolphin, William Millar, Brian Metcalf. Grizedale, Cumbria, England

*Snaking its way through a forest, this wall formed from piled stones is not a useful barrier. As an **Earthwork**, it functions more to make us think about the human desire to possess and mark off territory—and perhaps nature's ultimate independence from our control.*

people could invent and innovate. Since the twentieth century has generally embraced invention in all areas of activity, this fresh and impertinent notion influenced many people's thinking about art, as it continues to do. (See also pp. 94, 148.)

Earthworks

A type of **contemporary sculpture** created in nature, often very large and referring to phenomena such as the slow process of erosion or the movement of planets or stars, especially the sun. Many earthworks intend to help us understand nature better. Some demonstrate the inherent differences between nature and civilization, often pointing out humankind's desire to understand, conquer, and control natural processes.

Edo

The **period** (also called Tokugawa) when Japan was ruled by the warlords of Edo (1615–1868), prior to the opening of major trade routes to Europe and the **Western** Hemisphere. The **aesthetics** of the Edo period derive from the periods just before, such as those described under **Momoyama**. One of the most common Edo arts was "ukiyo-e" painting and prints (see **Floating World**), which depicted "fleeting moments" in both nature and everyday life. Woodblock **printing** was especially popular. Among the **sculptural** forms were miniatures called "netsukes," which continue to be popular among Western collectors.

Opposite:
Hiroshige (Japanese, 1797–1858). *Mannen Bridge, Fukagawa*, from the series One Hundred Famous Views of Edo. Edo period, 1857. Woodblock print, 13½ x 9″. The Brooklyn Museum. The Brooklyn Museum Collection

*In this print, ostensibly a view of the city of **Edo**, by a much revered Japanese artist of the nineteenth century, several things often found in Asian art stand out: the landscape, a sense of a great expanse of space, and objects placed to clearly indicate closeness as well as great distance. (See also illustrations, pp. 89, 96, 113.)*

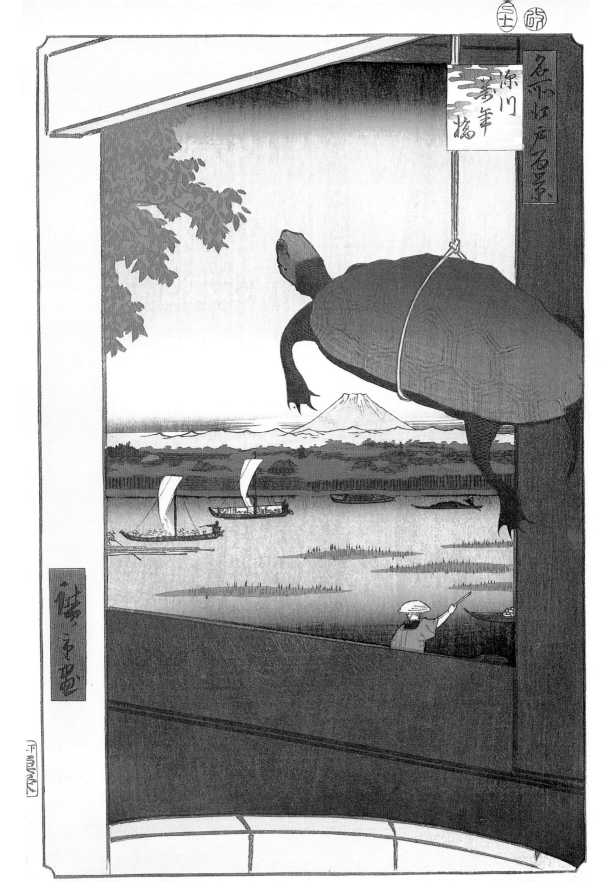

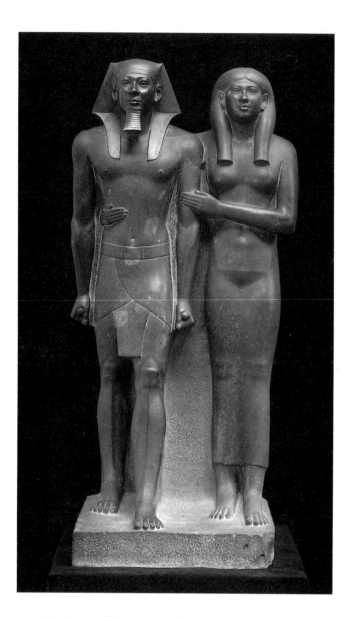

Pair Statue of Mycerinus and His Queen. From Giza, Dynasty 4, 2599–1571 BCE. Slate, height 54½". Courtesy, The Museum of Fine Arts, Boston, Harvard–Museum of Fine Arts Expedition

A royal couple from the Old Kingdom display some of the characteristics of this period of **Egyptian** *art. The figures are stepping forward in firmly held positions. They face us directly with open, almond-shaped eyes; the treatment of hair, headdress, and beard all add to the impression of their power.*

Egyptian

Art from the **African** land that has been called Egypt for more than five thousand years. It usually refers to objects, paintings, and architecture made between 3000 and 1000 BCE.

The pyramids and the great sphinx along the Nile River were constructed between 2680 and 2565 BCE, during the **period** known as the Old Kingdom (roughly 2680–2258 BCE). It was also during this time that the visual conventions we identify with **ancient** Egypt were developed—that of representing the human **figure** with head, pelvis, legs, and feet in profile and eye and shoulders facing front. Artists made few attempts to create a sense of **space** in the scenes they depicted and used clear outlines to communicate shapes. Much of what we have left of this art comes from tombs where sculpture and painting depict scenes of daily life, hunting, war, and ceremonies as if to insure that the dead could go on living as they had.

The short-lived Middle Kingdom (2000–1786 BCE) maintained much of the style and content of the Old Kingdom but tended toward more delicacy, and figures were more likely to contain readable emotional expressions.

The era in Egyptian art known as the New Kingdom (c. 1570–1342 BCE) produced lavish funerary tributes to the rulers Queen Hatshepsut, Akhenaten and his queen, Nefertiti, and Tutankhamen ("King Tut"). With the discovery of Tut's tomb in 1922, it was possible to see how naturalistic representation had become.

Ancient Egyptian culture is considered crucial to the development of art in Europe and the **Western** Hemisphere. Its influence on early **Greek** art is visible. It has also made its way into our life today, as in our fascination with mummies and the contents of tombs (see p. 115), especially jewelry.

Expressionism

Style of art that particularly emphasizes the expression of feelings. Sometimes this emphasis happens

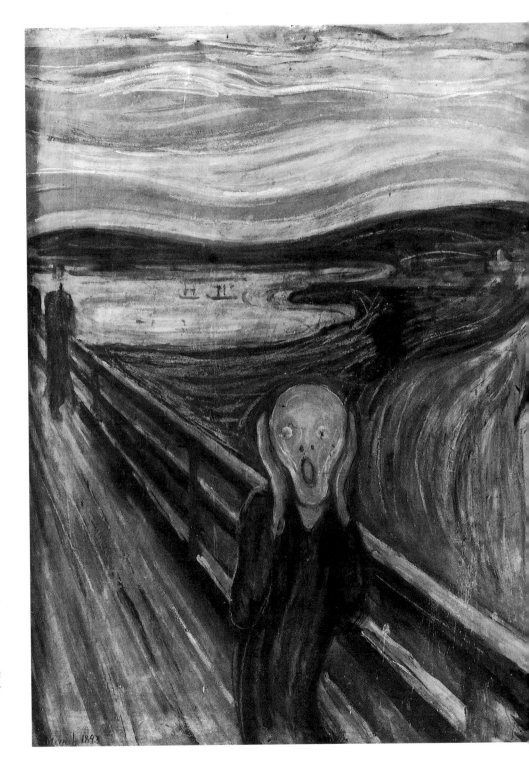

Edvard Munch (Norwegian, 1863–1944). *The Scream*. 1893. Tempera and oil pastel on cardboard, 35⁷/₈ x 29″. Nasjonalgalleriet, Oslo

Expressionist *art is full of emotional statement: In Munch's painting a skull-like, ghostly figure with bulging eyes crying out pushes us toward a reading of fear, anxiety, or even horror. We also see another somehow ominous figure approaching through the darkness and swirling water or air to add to the mix. The precise emotion and its cause are not clear, but the pathos of the scream is easy to feel.*

because the **subject** is charged with meaning—such as an image of war or bitter poverty. It is usually the result of other choices by the artist as well, for example using **colors** in an outrageous way, inscribing **lines** very boldly, or employing very jarring **shapes**. The artist's emotional attitude can be read to some degree in these decisions. Our responses are more likely to be emotional than intellectual in such instances as well.

This tendency was first seen in the work of artists such as Vincent van Gogh (see p. 69) and Edvard Munch, who used both colors and **gestures** to make a statement with their art. During the first decade of the twentieth century, artists in both Germany and Austria, known as "German Expressionists," coupled the use of harsh colors and strong dark lines with socially significant subjects, often criticizing the rich and powerful. Some German Expressionists emphasized elements of spirituality, again taking liberties with nature and especially using colors to move viewers beyond the physical world into one of feelings and associations.

By the middle of the twentieth century, artists had started to experiment with creating **abstract** paintings intended to have emotional impact. This movement was called "Abstract Expressionism," and it is one of the most celebrated of the styles developed as part of **modern** art (see pp. 15, 58)—and the first to be recognized internationally as **American**—reaching its height in the mid-1950s.

Fauve

The French word for "wild beast" (pronounced "fove") is applied to the work of a number of young artists in Paris who early in the twentieth century outraged an art critic with their bright **colors**, disregard for logic, and somewhat scribbly **drawing**. Their art seemed savage to the critic. He said so in a printed review of an exhibition—and the name stuck. To the artists, the issue was not savagery but attempting to move beyond the physical world into one of sensations. (See illustration, p. 2.)

Floating World

During the **Edo period** of the seventeenth and eighteenth centuries in Japan, the "floating world" was the subject of woodblock **prints** and **paintings**. Artists created elaborate scenes of "real" life with single or paired figures—actors, musicians, street vendors—and landscapes.

Folk

Folk art, in which schooling and academic training play little part, is handed down from generation to generation and usually reflects commonly held regional values and customs. Often not thinking of themselves as professionals, folk artists simply make things as a matter of course—quilts for example.

Categories such as "folk art" trouble some people, because they imply qualitative distinctions between, say, fine art and folk art, or high art and popular culture. There are indeed differences in the training and motives of the artists, among other things, but using "fine art" to suggest superiority is no longer seen as reasonable. We use labels to help us sort things out but not to confer judgments.

Futurism

In the early part of the twentieth century, a number of Italian artists looked around them and saw change taking place in the world—particularly in the mechanical and technological arenas. They were especially excited by the speed at which things were occurring, moving society toward tomorrow faster than ever thought possible.

They formed a group calling themselves "Futurists," and their goal was to embody the energy of a world that was constantly changing, building, growing. They did this by using bright **colors** that glow with intensity. Even more, they used overlapping and repeated **lines** and **shapes**, and edges are blurred. Although you can find objects, animals, and sometimes athletes in Futurist art, above all you get the sense of energy and power as **forms** move through **space**.

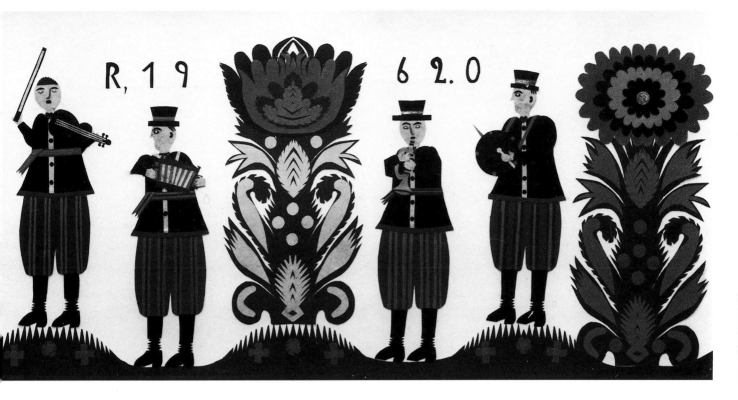

Zofia Wiankowska (Polish, b.d. unknown). *Musicians.*
1962. Cut paper. The Girard Foundation Collection in the
Museum of International Folk Art, a unit of the Museum
of New Mexico

*Musicians dressed in traditional garb—simple, easily read,
but not naturalistic—are typical of **folk** art. So is the concern
for pattern evident in both the little hills and valleys and the
oversize, symmetrical flowers.*

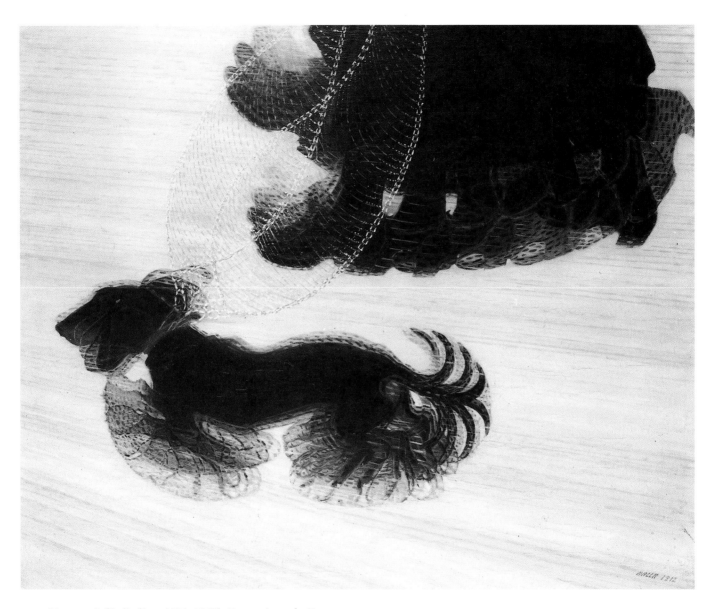

Giacomo Balla (Italian, 1871–1958). *Dynamism of a Dog on a Leash*. 1912. Oil on canvas, 35³/₈ x 43¹/₄". Albright-Knox Art Gallery, Buffalo, New York. Bequest of A. Conger Goodyear and Gift of George F. Goodyear, 1964

*Although most **Futurist** art depicted machines, athletes, or the hustle and bustle of cities—often abstracted—to convey an interest in the power and movement of the modern era, this is an example of the whimsy that is possible within the style.*

Gothic

From the late twelfth to the fifteenth century, the Gothic **style** was the predominant **architectural form** in Europe. Influenced by many of the spiritual concepts of the era, Gothic churches are characterized by soaring heights and **light**-filled open **spaces**.

While domed and round-arched structures represented the highest buildings of the **ancient** world, Gothic architecture extended heavenward with the help of at least two inventions: a new kind of pointed arch and an exterior anchor called a "flying buttress," which bore much of the weight of the increasingly higher walls. Instead of the thick stone masonry and small openings required to support earlier **Romanesque** structures, windows line the walls of Gothic buildings, filling interiors with sunlight filtered through stained-**glass** scenes of religious figures and stories. Columns are delicate in appearance, seeming to be made up of bunches of small columns, and their vertical lines pull our eyes upward toward the churches' vaulted ceilings.

Graffiti

Refers to the age-old practice of writing or drawing on public walls. Beginning in the 1970s, most major cities of the United States experienced the practice, popularized by teenagers set upon marking their territories with their names and other personal insignia. Graffiti (most often referred to by its plural form) is one form of "street art"—that is, creative statements, usually making some kind of social comment and appearing in public spaces, such as on sidewalks, building walls, and billboards.

Greek Art

Art created on the peninsula now called Greece and many nearby islands in the Aegean Sea, including Crete, home to Minoan culture, active c. 3000–1400 BCE, when it was subsumed by the Mycenaeans, who were in turn invaded by the Dorians and other barbarian tribes c. 1000 BCE. The resulting decline in artistic activity was followed by the grad-

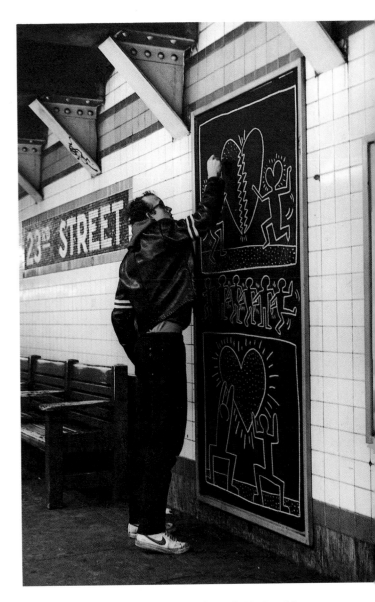

Keith Haring (American, 1958–1990). *Keith Haring: New York City Subway System Drawing.* 1983. White Chalk on Advertising Space

*The use of **graffiti** was pushed to new lengths in the 1980s, with artists like Keith Haring taking to the New York streets and subways with messages that ranged from comments on violence and AIDS to the need for more compassion among people.*

Rose window and
lancets, north transept,
Chartres Cathedral,
France. 13th century.
Stained glass.

*One of the most beautiful
developments of the
Gothic period were huge
walls of stained glass. The
upper, circular window is
called a "rose window"
and the vertical ones
below, "lancets," named
for the windows' arched
shape.*

ual emergence of what we consider Greek art, beginning with pottery decorated with distinctive geometric **patterns**. The "archaic" **period** (c. 660–480 BCE) marked a return to representation and the dominance of **sculpture**, especially statues of nude walking **figures** called "kouroi," at first having many of the stiff and formal characteristics of **Egyptian** art. This period was also known for elaborate **schools** of vase **painting**, working in black-figure and red-figure styles.

To most historians and philosophers of the **Western** world, the so-called **classical** period (c. 480–400 BCE) was a high point in cultural achievement, setting standards of beauty, humanism, and other ideals honored to this day. Much of the art—even poetry and music—was based on systems. For example, Greek **architecture** depended on the "column" to support the weight of the peaked roofs. Various column types, or "orders," were developed, the three most common being Doric, Ionic, and Corinthian. The triangle created by the sloping roofs was called the "pediment" and became the site for sculptural **reliefs**. Sculpture involving the figure became increasingly **idealized**, seeming less like real people than perfect representations of athletes or gods and goddesses. In **carving** and **craft**, artists increasingly sought perfection of **form**.

Increasingly dynamic expressions, **gestures**, and body positions, adding emotional depth to the always-present harmony and balance, were the accomplishments of the "Hellenistic" period, ushered in by the Macedonian conqueror Alexander the Great in 375 BCE and lasting until the **Roman** conquest of the area in the mid–first century BCE. Greek sculpture comes down to us mostly because the Romans made copies of many Greek statues, and all our knowledge of the arts owes a great debt to archaeology.

Gupta

While the rulers of the Gupta dynasty (c. 320–55 CE) took and maintained power over much of northern

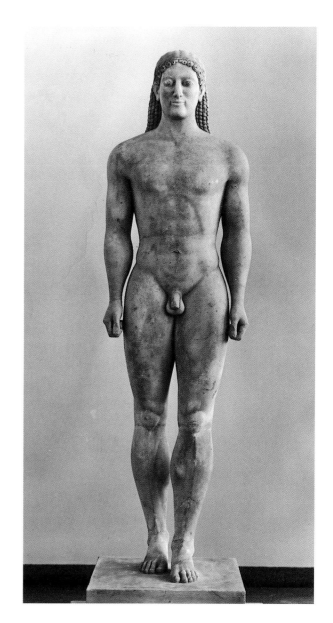

Kouros from Anavyssos, Greece. c. 525 BCE. Marble, red paint on hair, headband, pupils. height 6'. National Archaeological Museum, Athens

*Compare this figure of an athlete from archaic **Greece** to the male figure from Egypt on p. 40. They hold almost the same pose, but here one can see increasing naturalism. Unlike the Egyptian king, the Greek athlete is nude, more defined anatomically, and even seems to be smiling.*

47

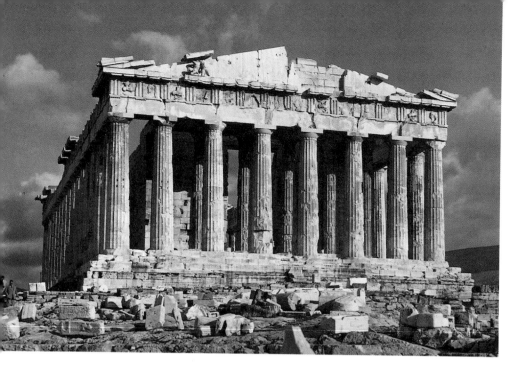

Ictinus and Callicrates. Exterior of the Parthenon (view from the west), Athens, Greece. 448–32 BCE

*This famous building, now a ruin, stands as a symbol of the architectural achievement of classical **Greece**. It is a carefully proportioned structure, supported by columns (the Doric Order was used on the outside, and the more delicately proportioned Ionic columns supported a smaller inner hall) with a peaked roof.*

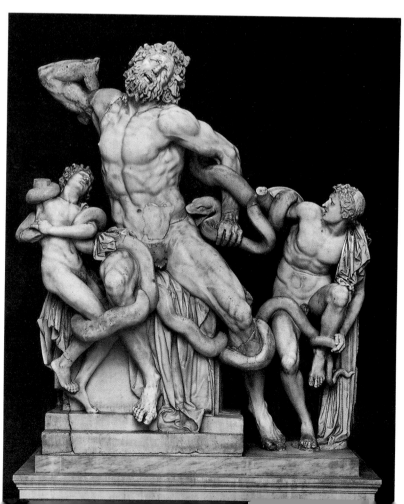

The Laocoön Group. Roman copy of Hellenistic Greek original, perhaps after Agesander, Athenodorus, and Polydorus of Rhodes. 1st century CE. Marble, Height 7'. Vatican Museums, Rome

*Hellenistic **Greek** art is highly naturalistic. While figures might appear to be posed, one can see accurate depictions of anatomy, movement, and gesture, and sometimes even personal characteristics. (See also illustrations, pp. 9, 27.)*

India, **sculpture,** wall **painting,** and **architecture** thrived, and the **period** is referred to as the "Golden Age" of Indian art. Although the rulers were **Hindu,** they supported the last important period of **Buddhist** art in India, creating much of the **imagery** that followed the religion as it spread elsewhere in **Asia** (see, for example, the Chinese figure on p. 32) while diminishing in influence in India. Guptan art achieved a high degree of **realism** in objects of worship that balanced refined simplicity with a love of **decoration. Reliefs** recorded events in the lives of religious figures. Notable accomplishments include the **carvings** of the cave monastery at Ajanta, where portions of a once extensive **fresco** cycle also remain.

Han

The reign of the Han dynasty (206 BCE–220 CE) is considered the first "imperial age" of China. It is recognized for its long-lasting political calm and economic stability as well as high achievement in technology and the arts—a phenomenon that outlasted the dynasty itself. During this time, histories and dictionaries were written, and the teachings of **Buddha** were introduced from India. Extravagant court life took on new prominence. **Painting** began to emerge as a major expressive art, depicting historical events and making comments about society.

The legacy of the Han dynasty includes work in many **mediums**—terra-cotta tiles and **figures** (see p. 56) of many sorts (horsemen, dancers, peasants), decorated **bronze** vessels and mirrors, gleaming lacquer objects, and elaborate **costumes.** Exquisitely refined **craftsmanship** in **ceramics,** metalwork, and silk set standards of virtuosity and elegance respected today in much of the world.

Among Han **architectural** achievements are cave temples containing numerous statues of the Buddha in attitudes of meditation and prayer. In a process that extended into the sixth century (Northern Wei dynasty), representations of Buddha gradually took on more typically Chinese features

as well as other characteristics we associate with him—his roundness, his large nose and ears, his calm elegance.

Heian

During this **period** of Japanese history (794–1185), the court and government were located in Heian-Kyo, now known as Kyoto, where they remained until the mid-nineteenth century. The era is marked by a move away from Chinese **cultural** influence and toward themes and stories more distinctly Japanese; Heian **paintings,** "yamato-e," reflected this nationalistic shift in **subjects.** A dominant **medium** was "scrolls," which were detailed, emotion- and action-filled paintings on paper or thin cloth mounted on silk. Scrolls are often very large and kept rolled when not displayed.

Hindu

The art of Hinduism, the name given to the principal religion of India, which began its development as early as 2000 BCE, drawing from a variety of sources and spreading to other parts of southeast Asia. Its best-known forms are sacred **bronze** and stone **sculptures** of gods such as Brahma, Vishnu, Siva, and, later, Krishna (an incarnation of Vishnu), as well as ornate stone buildings and temples and domelike shrines.

Hindu art can be recognized by its energy and vitality. There are many repeated **symbols,** such as fire or the lotus blossom (a flower sacred in a number of religions), and representations of holy beings standardized with the many indicators of their deeds and domains. Hindu art combines the earthly with the spiritual more than is found in most religious art. (See illustration, p. 17.)

Impressionism

Style now greatly admired that shook the foundations of European art in the late nineteenth century and had a profound impact on all art that happened after it. The pretty **subjects** of Impressionist **paint-**

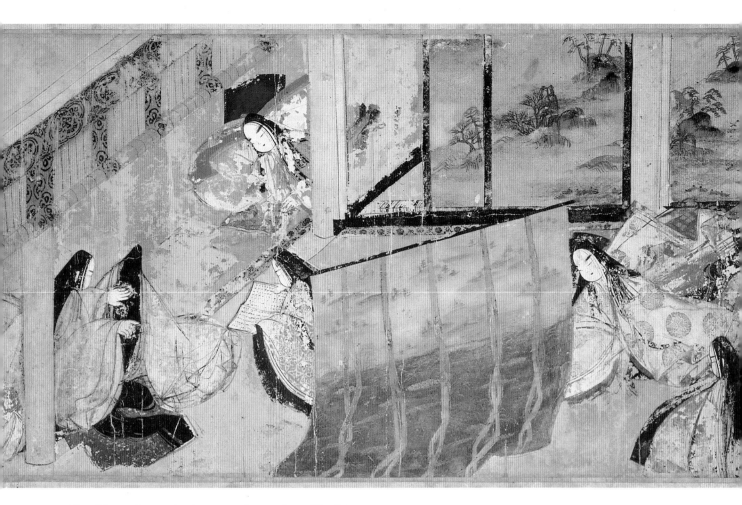

First illustration to the Azumaya chapter, from *The Tale of the Genji*. Late Heian period, 12th century. Handscroll: ink and color on paper, height 8½". Tokugawa Art Museum, Nagoya

The Tale of the Genji, *a novel written by Lady Murasaki in the early eleventh century, is a long, complex story of the activities of the emperor's court and the aristocracy of Kyoto during Japan's* **Heian** *period.*

ings and the way they were painted seem delightful more than one hundred years later. At the time, however, they were a great affront to accepted standards of painting.

Impressionists often painted entire works outdoors (as opposed to sketching outdoors and creating the final work in the studio), unusual in itself at the time. Using bright **colors** and painting with very visible **brushstrokes**, they sought to capture immediate sensations, quickly observed. They were particularly interested in light as it struck various surfaces in different weather and at different times of day (see p. 19). Their **subjects**, including many people at leisure, were more ordinary than they were lofty and sometimes seem to be only an excuse for depicting a fleeting mood and look of a moment in time.

Installation

A type of **sculpture** that takes over and alters the space where it is installed, usually temporarily. It is an important aspect of **postmodern** art, reflecting a tendency among some artists to produce work that is "site specific," which means that it relates specifically to the place where it was created and would not be the same if moved elsewhere. Installations are often very large, involve creative uses of lighting, and resemble **architectural spaces**, sometimes filled with objects.

Installations have their roots in the temporary constructions of **Minimalists** and in the events called "Happenings" that had a moment in the late 1960s and early 1970s. All engage us actively as viewers in that we experience changes in scale or look at unfamiliar materials—or unexpected ones— used in new ways.

Islamic

Art that comes from areas of the world—primarily northern **Africa**, the Middle East, and Pakistan— that follow the teachings of the prophet Mohammed and the religion known as Islam.

Ned Smyth (American, b. 1948). *Roman Gothic Arcade*. 1976. Installation of concrete forms, Holly Solomon Gallery, New York

*An **installation** of simplified concrete columns with ancient influences dominates a contemporary gallery space, taking it back in time. The single ball might represent a timeless symbol like the globe, or a Minimalist sculpture.*

51

Islamic art has the same regional sources as **Byzantine** art. There are no representations of Allah (the god of Islam), and **figurative** art from Islam, always in small scale, chronicles social and political history. Colorful **mosaics** and tile work are characteristic of Islamic **design** (see p. 54). Its **architecture** is marked by domes, arches, and minarets. Hand-bound books with brightly and carefully **painted** illustrations, other miniature paintings, and beautiful **calligraphy** are also elements of Islamic art.

Kamakura

Named for its location, south of present-day Tokyo, the Kamakura **period** (1185–1333) saw a new **realism** in Japanese **portraiture**, expressed in both **painting** and **sculpture**. The Minamoto clan ruled a feudal society, evidenced by armor of unprecedented beauty and strength. Many structures and much art was destroyed as the shogunate came to power, and much of the restoration was influenced strongly by elements of Chinese art. **Buddhist** art was prevalent, including the first examples of Zen-influenced **imagery** (i.e., spare and asymmetrical), although scenes of violent battles and other tumultuous historical events were also depicted.

Kinetic

Type of **sculpture**, initiated by Alexander Calder's "mobiles"—works that were engineered to move with wind currents yet stay balanced. Kinetic art is an extension of earlier artists' interest in creating a sense of movement in static art as well as in the technologies—with their dual capacities to help and harm—that have so changed movement in the twentieth century. Kinetic art not only implies movement (like **Futurist** painting does) but also actually moves, whether naturally or by dint of artificial power.

Mannerism

A European style in **painting** and **architecture** that lasted throughout the second half of the sixteenth

Alexander Calder (American, 1898–1976). *Red Petals.* 1942. Painted iron, height 9′2″. The Arts Club of Chicago

*Anchored by its own sturdy metal structure, the long and delicate arm of Calder's **kinetic** mobile moves when touched by hand or wind.*

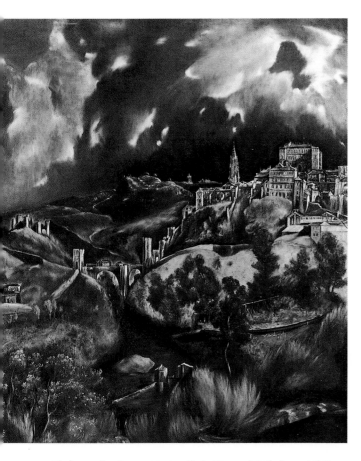

El Greco (b. Crete, 1541–1614). *View of Toledo.* c. 1570. Oil on canvas, 47³/₄ x 42³/₄". The Metropolitan Museum of Art, New York. Bequest of Mrs. H. O. Havemeyer, 1929. The H. O. Havemeyer Collection, 1929 (29.100.6)

To appreciate the inventiveness and individuality of the Mannerists, compare El Greco's landscape scene, featuring the Spanish city of Toledo in the distance, with the Renaissance painting by Piero della Francesca on p. 77.

century. Coming at the end of the **Renaissance**, it can be seen as a reaction to some of the artistic values of the earlier time. Mannerists used **colors** that were harsher than those of Renassiance artists. They went out of their way to distort reality, especially scale, and experimented with confusing **perspective**, unbalanced proportions, twisted elongated **shapes**, and uncomfortably posed **figures**. Artists sought to express emotions, often their own, rather than abstract ideals or perfected nature. They were more interested in the moment than eternity. Mannerist architecture tends to be very grand and elegant, often incorporating exaggerated proportions.

Medieval

Refers to an era in European history, often called the Middle Ages, dating from the fall of the **Western Roman** Empire, in the fifth century, to the fifteenth century, by which time the **Renaissance** had taken hold. The term encompasses a rich variety of **periods** and **cultures**, including **Byzantine,** Carolingian (8th–late 9th century), Ottonian (c. 900–1050), **Romanesque,** and **Gothic**.

Christianity was the unifying force of medieval culture; much of the art of this period relates to the Catholic Church, including the Crusades. The church authorized what the artists depicted in their work, which was often made for religious settings or to indicate the piety of wealthy and aristocratic patrons. Full of **symbols** that were very meaningful to the people of the day, medieval art was used to teach and underscore Christian history, beliefs, and values.

We know names of almost no medieval artists and few can be recognized by an individual style. The character of awe that was a part of medieval Christianity is reflected in the painstaking **craftsmanship** involved in copying and illustrating religious texts, **carving** intricate devotional objects and elaborate **architectural sculptures**, as well as creating lavish objects of metal, **glass**, and precious stones used in religious observations.

Opposite:
Panel of wall tiles. Turkish, late
16th century. Faience, painted and
glazed, 47 x 48″. The Metropolitan
Museum of Art, New York. Gift of
J. Pierpont Morgan, 1917
(17.190.2083)

Bright, lively patterns are typical of
Islamic *art. Sometimes they are*
complicated geometric shapes, often
interwoven. At other times they are
intricate designs of natural forms, as
here.

Chalice of the Abbot Suger of
Saint-Denis. 2nd–1st century BCE
(cup); 1137–1140 (mounting).
Sardonyx cup with heavily gilded
silver mounting, adorned with fili-
grees set with stones, pearls, glass
insets, and opaque white-glass
pearls; height 7¼″. National
Gallery of Art, Washington, D.C.
Widener Collection. © 1994 Board
of Trustees

This elaborate chalice was used in
celebrating the sacrament of Holy
Communion in the **medieval**
Christian church. The ancient cup
was encrusted with jewels to make
it a vessel worthy of serving wine, a
symbol of the blood of Christ.

Tomb pit with part of earthenware army of the First Emperor of Qin, Lintong, Shaanxi, China. 221–206 BCE

*A ceramic army of uniformed soldiers and functionaries was buried in formation with this Chinese emperor, an enduring **memorial** to a ruler's power and authority. The first Qin emperor began China's Great Wall as well as a system of roads and standardized coinage and measures, but his harsh reign was short-lived. His death in 210 BCE paved the way for the first emperor of the Han dynasty, which would endure for four centuries.*

Maya Ying Lin (American, b. 1960). Vietnam Veterans Memorial, Constitution Gardens, Washington, D.C. 1981–82. Black granite, height 10'; length 500'

*Cutting deep below ground level, this **memorial** listing of those who died during the years of the Vietnam War commemorates in an affecting way the toll taken in American lives.*

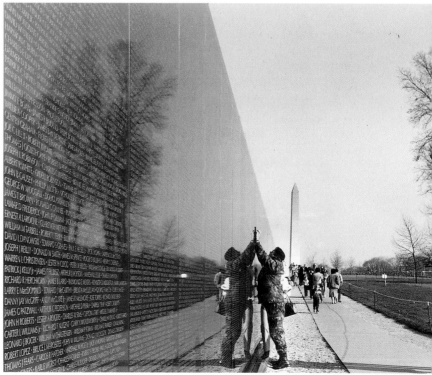

Memorials

Art created to recall and honor the memory of some person, group, or event, such as a political leader or valiant warriors in battle. Such commemoration can be as old as the magnificent tomb pit of the self-proclaimed first emperor of China, guarded by a vast earthernware army, from the third century BCE, or the **ancient** Colossus at Rhodes, built to mark the greatness of the city. It also includes the **portraits** or effigies of four United States presidents **carved** into Mount Rushmore as well as the Vietnam Veterans Memorial in Washington, D.C.

Ming

One of the most famous **periods** in Chinese art history (1368–1644). Artists of the Ming dynasty are acclaimed for beautiful porcelain—much of it made specifically for export—**sculptures** of jade, ivory, and **glass**, complex **designs** for parks and gardens, and magnificent paintings.

Because the Ming rulers were in power when European explorers and merchants first initiated regular trade between the **Asian** and European continents, theirs was the first Chinese art to be widely known in the **Western** Hemisphere. Perhaps because of this, the **forms** and styles of the Ming dynasty define our notions of Chinese **culture** more than they really should.

Minimalism

In the 1960s and 1970s, particularly in the United States and Europe, there developed in some art a trend toward great simplicity. Following the lead of earlier artists who "reduced" **painting** to **abstract** geometric arrangements, a group of artists began to pare art down even further to the barest essentials: just **materials** (often ones not originally designed for art) and **shapes**.

The look of Minimal art is easy to imagine, hard to reproduce in photographs. Materials range from industrial fabrics to lead to fluorescent or

Agnes Martin (American, b. 1911). *Untitled/Grey Geese Descending*. 1964. Ink on paper, 6 x 6″. Private collection

*A **Minimalist**, Martin uses lines, often drawn in the form of a grid, to produce a very subtle effect on her surfaces. As the second part of the title suggests, the lines evoke specific images for the artist.*

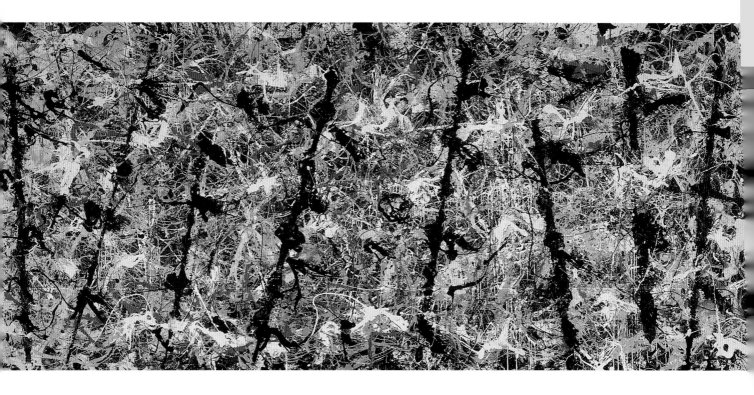

Jackson Pollock (American, 1912–1956). *Blue Poles*. 1952. Oil, synthetic polymer paint and aluminum paint, glass on canvas, 6'11" x 15'4⁹/₁₆". National Gallery of Australia, Canberra

*Among the inventions that Pollock brought to **modern** painting was laying his canvases on the floor and using ordinary materials like house paint to make huge works. Reaching in from all sides of the canvas, he would drip, fling, and squirt paint, breaking all sorts of rules—as twentieth-century pioneers in all fields have done.*

neon light to barely visible pencil marks on canvas or paper. A predominant shape or **form** may be repeated many times over. Most Minimal art is black and white; if colored at all, it is very subtle and subdued. It is often very large. Minimal artists frequently depend on machines to make their art, and even if hand made, the work appears to retain few personalizing marks of the maker.

Like much **modern** and **postmodern** art, Minimalism calls into question the role of the artist and the nature of creativity.

Modern

A term first applied to a time **period** beginning in the 1880s, when a radical change in artists' attitudes toward art took place. New times demanded new ("modern") art. Building on the **Impressionists'** steps away from **tradition**, modern artists championed invention and innovation, along with individuality—each artist needing his/her own defining

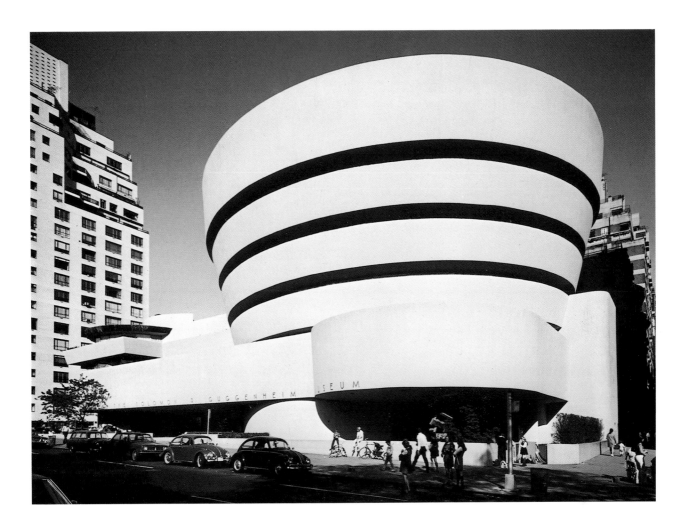

Frank Lloyd Wright (American, 1876–1959). Exterior of The Solomon R. Guggenheim Museum, New York. c. 1957

*Given a chance to design a building to showcase the new, mostly abstract art of the **modern** era, the innovative architect Frank Lloyd Wright invented a whole new concept in gallery space, incorporating circular rooms and an ascending spiral ramp with bays for exhibiting art.*

style, even within groups committed to similar principles.

In the modernist drive toward originality and uniqueness, impatience with the past became a rule, not just an attitude. The result was a kind of intolerance toward artistic traditions, especially **realistic subject** matter. There was a strong assertion that **abstract** art was the language for our times. Moreover, art had to play in the realm of the mind as much as that of the eye or senses, as it does with **Surrealism**, for example. Much modern art became strongly dependent on a pared-down vocabulary of **lines**, **shapes**, **forms**, **colors**, and **patterns**,

perhaps most readily characterized by **architecture** of **glass** and steel, **paintings** that focus on geometry and/or color only, or large expressive canvases covered with masses of lines and amorphous shapes.

One reason for the modernist enthusiasm for abstraction was its belief that **materials** themselves could contribute as much to meaning as subject matter. Modern artists used thick paint, rough **brushstrokes,** or hard, rough metals to make statements, often trying to visualize complex matters such as the workings of the interior mind, ongoing warfare, and holocausts—things that defy precise visual (or verbal) description. On a more positive side, they also looked at the world as a single village needful of a universal language achieved through color and **gesture.** See also **Abstraction, Conceptual Art, Cubism, Dada, Earthworks, Expressionism, Fauve, Futurism, Minimalism, Post-Impressionism.**

Momoyama

A **period** in Japanese history (1573–1615) when the country was governed by warlords living in the castle towns of Anzuchi and Momoyama. Characteristic of the period is its **architecture**: stone buildings many stories high with curving tile roofs that overhang each ascending story. The building profiles are marked by gables with ornamentation along the eaves. Interiors were often open and plain, decorated only with spare, skillfully **painted** screens, door panels, and wall **murals** of typical Japanese themes—famous places, the seasons, pines, reeds, turbulent seas, and boats. The simple beauty of the interior **decoration** has had a strong impact on later **Western** sensibility.

During the Momoyama period, appreciation for the contemplation of perfection, spareness, and purity was exemplified by a particularly spartan form of the tea ceremony—a slow and ritualistic way of sharing the drink that allowed ample time for consideration of the beauty in small gestures and simple vessels.

Hime-ji (called Shiragasi, Castle of the White Herons), Hyogo, near Osaka, Japan. Momoyama period, 1601–9

Marked by prominent overhanging eaves, the floors of this **Momoyama** *castle are clearly delineated. The curved gabled and tiled roofs are often set at opposing angles to each other, creating a complex, asymmetrical pattern in contrast to the simple interiors.*

Mughal

Refers to the Muslim empire in India, 1526–1857, during which a distinctive **style** arose, especially in northern India. A **school** of Mughal painting was begun in 1549 with the invitation of Persian painters to the imperial court at Kabul. As the Mughal style developed, **drawings**, **costumes**, and **illuminated manuscripts** combined elaborate **Islamic patterning** and bright **colors** with Indian-influenced landscape detail and **Western**-influenced **modeling** and **perspective** (see illustration, p. 127). The most famous monument of Mughal **architecture** is the magnificent Taj Mahal at Agra, built as the tomb of the favorite wife of Shah Jahan (1628–58).

Muromachi

A **period** (1392–1573) when the shoguns of the Ashikaga family ruled Japan from their palace in the Muromachi district of Kyoto. While the era was marked by fierce conflicts and fighting, the shoguns themselves paid a great deal of attention to aesthetic matters, turning once again to China for inspiration. The influence of Zen **Buddhism** marked the art and religion of the period, during which an especially spare form of tea ceremony developed. Although the more conservative artists followed the **Heian** "yamato-e" **tradition**, others adopted the **Song** style of monochromatic (single-color) **painting** in ink. **Architecture** often served contemplative purposes and combined refined materials with natural elements left rough, as if to underscore a rapport between humans and nature. Gardens for contemplation—containing a few carefully placed rocks ("islands") on sand or pebbles ("water")—were introduced (see p. 32).

Naive

A descriptive term applied to art made by individuals who were not trained as artists. The work often

Henri Rousseau (French, 1844–1910). *The Dream.* 1910. Oil on canvas, 6'8½" x 9'9½". The Museum of Modern Art, New York. Gift of Nelson A. Rockefeller

Rousseau was highly appreciated by other artists at the turn of the twentieth century. His distorted scale, unlikely scenes, and fanciful notions about people and places he had never seen resulted in pictures many modern artists found refreshingly innocent and **naive** *in a complimentary sense of the word.*

Playing cards. Arizona. Apache, n.d. Painted rawhide, each 3½ x 2¼". Courtesy of the National Museum of the American Indian, Smithsonian Institution, New York

These cards incorporate simplified representations of people, animals, and objects and repeated patterns.

Opposite:
Figure of Kachina. Southwest Arizona. Hopi, c. 1900. Cottonwood and paint, height 26½". The Montclair Art Museum Permanent Collection

In rituals, costumed dancers personify kachinas—deities responsible for the harmony of the universe to many pueblo peoples of the southwestern United States. Carved and painted figures like this Hopi Pahlik Mana kachina have no ritual purpose but are kept at home to represent, between cyclical ceremonies, the spiritual attributes of the kachinas.

looks as if it were made by children because it pays no attention to the conventions of academic training that we associate with "fine art."

Naive art is related to **folk** art, in which images and emotions are also expressed very directly and simply. Their meanings, however, can be elusive unless you are filled in on the culture from which they come. In many instances this is not a simple matter; some naive art is made by people whose realities are narrowly defined, such as patients in mental hospitals, whose art is sometimes referred to as "Art Brut." In this general category falls art known by other names, such as "outsider," "tramp," or "prison" art.

Native American or American Indian
Refers to art of ethnic groups scattered all over the North American continent when its conquest and colonization began more than five hundred years ago. At present it is preferable not to use such broad terms, in part because it lumps people according to race, not considering their distinctive **cultures** and ways. Instead, we are encouraged to think in terms of the art of a particular ethnic grouping, such as the Inuit from Alaska and the Hopi from the southwestern United States.

Much Native American art is made of natural materials, and it often has an important function in daily life. It also often has religious and ceremonial uses, which are harder to understand without specific knowledge of the particular people.

Neo-, or Revival
A prefix placed before an artistic style to indicate that it is being borrowed back from history. For example, in the latter half of the nineteenth century, the Neo-**Gothic** (also called Gothic Revival) style recycled the pointed Gothic arch, among other details, to give residences, churches, or university buildings an air of great age and respectability.

Neoclassicism

A reference to the revival of ancient **Greek** and **Roman** models and standards of achievement occurring at various moments in more recent history. For example, around the American and French revolutions, as the new republics tried to create governments "of the people," there was great interest in these **ancient** civilizations, considered the birth sites of democracy. It struck politicians of the day—as well as their artist counterparts—that all sorts of **classical** precedents might be emulated to good effect. Thus arose the movement referred to by historians as "Neoclassicism." Artists turned to the standards of **ideal** proportion, beauty, and order that were admired in these cultures. These influences were most easily seen in **architecture**—consider courthouse buildings with grand columns and wide steps—but occurred in **painting** (see p. 140, above), **sculpture**, literature, and music as well.

Neo-Expressionism

A style, particularly of the 1980s, that revived the use of jarring **colors** and very obvious **brushstrokes** to infuse **painting** with energy and feeling. The movement included both **abstract** and representational art and borrowed its techniques (use of color, **line**, and brushwork) from earlier **Expressionists.** The content of those Neo-Expressionists who included recognizable subject matter also tended to be provocative, for example, bringing up subjects in public that are normally considered private concerns, such as the dawning of sexuality in adolescents.

Oceanic

Applies to art produced by the island peoples of the South Pacific, especially Melanesia: New Guinea and the islands to the north and east; Micronesia: the Marianas, Caroline, Marshall, and Gilbert islands; and Polynesia: Hawaii, New Zealand, the Marquesas, and Easter Island. Examples of Oceanic art range from Melanesian wood **carvings** and ritual masks (see illustration above) that were brilliantly

Gable Mask. New Guinea. Middle Sepik Haug, n.d. Painted wood, height 36⅝". Linden Museum, Stuttgart

Opposite:
Luis Cruz Azaceta (American, b. Cuba, 1942). *AIDS Counts III*. 1989. Acrylic on canvas, 6'5" x 9'9". Courtesy of Frumkin/Adams Gallery, New York

An emaciated, disfigured yet still-living form hauntingly gazes out from a coffin-shaped bed surrounded by numbers, as Azaceta counts off an endless census of those dying of AIDS. Not only conceptual, this image can be compared to Munch's The Scream *(p. 41) because of its conscientious attempt to address the feelings involved with facing a devasting epidemic, qualifying it as a* **Neo-Expressionist** *work.*

colored and covered with characters and **symbols** to illustrate complex mythologies to the huge stone figures of Easter Island (see p. 7). What we call Oceanic "art" usually had a well-defined function in ritual or ceremony or as identifying markers of particular places or beings.

Op Art

A type of **painting** and **drawing** that concentrates on creating optical effects to convince our eyes that there is motion where there is none. The sensation of movement is achieved by the interactions of **colors** that seem to vibrate when placed next to others, by strong contrasts in light and dark, and by certain kinds of **patterns**, such as wavy **lines** that run parallel but vary in distance from one another.

*Not only do our eyes react to this dizzying **Op Art** pattern as we stare at it, but moving them or our position increases the sense of swirling motion. At some points the closeness and size of the lines give the impression of colors that are not actually there.*

Period

It is often easier to study something when it is broken into small units. Historians do this by breaking time into spans called "periods." The Middle Ages is an example of a lengthy era, and the **Gothic** period a roughly 400-year stretch within it. Some periods are named for rulers, as in Elizabethan England (1533–1603), named for Queen Elizabeth I; or for families that continued to rule as dynasties, such as the **Tang** dynasty in China.

Pointillism

A late nineteenth-century **painting** technique that used small dots of paint (a process often referred to as "stippling") to compose a picture, often an outdoor scene. When viewed from a distance, the dots

Clockwise from above:
Panelled room. Rococo, 18th century. Installation, Collection of The John Paul Getty Museum, Malibu

Interior of the Plympton House (orig. New England). American Colonial, 17th century. Period installation from the collections of Henry Ford Museum & Greenfield Village, Dearborn, Michigan (A 4847)

Frank Lloyd Wright (American, 1867–1959). Living room from the Francis W. Little House (orig. Wayzata, Minnesota). Installation in the American Wing of The Metropolitan Museum of Art, New York, Purchase, Bequest of Emily Crane Chadbourne, 1972 (1972.60.1). Installation through the generosity of Saul P. Steinberg and Reliance Group Holdings, Inc.

*Museums often re-create **period** rooms to evoke a sense of a particular time through its architecture, paintings, furniture, and decorative objects.*

Georges Seurat (French, 1859–1891). *A Sunday Afternoon on the Island of La Grande Jatte*. 1884–86. Oil on canvas, 6′9″ x 10′. The Art Institute of Chicago. The Helen Birch Bartlett Memorial Collection, 1926.224

*In this, one of the best-known of **Pointillist** works, Seurat not only exhibits his technique of painting but also his interest in the people of Paris at leisure.*

Vincent van Gogh (Dutch, 1853–1890). *The Starry Night.* 1889. Oil on canvas, 29 x 36¼″. The Museum of Modern Art, New York. Acquired through the Lillie P. Bliss Bequest

*When this **Post-Impressionist** image is compared to that of Seurat opposite, it becomes clear that this productive period at the end of the nineteenth century cannot be defined by a single style. Compare it to Munch's* The Scream *(p. 41) to see more ways artists attempt to direct the feelings of the viewer. In this case it is not so much the subject—a vivid night sky over a sleepy village in the mountains—but the colors and the broken lines with which the paint is applied that make it an emotional statement.*

Marisol (American, b. Venezuela, 1930). *Women and Dog.*
1964. Fur, leather, plaster, synthetic polymer, wood,
72 x 82 x 16″. Collection of Whitney Museum of American
Art, New York; Purchase, with funds from The Friends of
the Whitney Museum of American Art

*By carving, painting and drawing in wood, and adding a few
actual objects, **Pop** artist Marisol portrays but makes no sub-
stantive comment on contemporary culture. Here she includes
a self-portrait: the second figure from left has her face.*

meld to create the impression of other **colors**, as well as **forms**, **figures**, and surfaces such as water. Sometimes called "Divisionists" (the most technically accurate term) or "**Neo-Impressionists**" (because of their concern with light and its effects on surfaces and shapes), Pointillists were fascinated by science and new understandings of what is "real." The effect was to make our eyes do the mixing of colors, reflecting the knowledge that, in painting, all colors can be made by combining the "primaries"—red, blue, and yellow.

Pop Art

A movement that dominated the 1960s in which artists used the intensely rich world of popular and commercial images, from soup cans to comic strips and billboards, both for inspiration and as **subject** matter for their art. These artists observed that, after World War II, visual **culture** expanded dramatically by way of package design, advertizing, films, and television. As the public became acutely tuned into popular **mediums**, it became alienated from the milieu and ideas of **modern** art. Pop artists, as they came to be known, tired of abstraction's vague meanings and grand hopes. They mined pop culture to see what was being said beneath the mass of communications, applying the imagery of the everyday to **sculpture** and **painting**. Pop artists shared considerable respect for modern culture's inventiveness, energy, and brightness but also treated it with humor and irony.

Post-

Literally meaning "after," this term is used in art to describe **periods** that define themselves in response to those that came just before. Often these periods are hard to capture in one word, because a number of distinct artistic visions can be discerned, none of them dominating others, and none spawning a **school** with many adherents. Artists of Post- periods more often are rejecting the earlier style, rather than building on it.

Post-Impressionism

Painters in this late nineteenth-century **period** turned away from the interests of the **Impressionists**, focusing less on surfaces and fleeting effects and more on personal concerns, emotions, and even spiritual matters. Paul Cézanne, for example, objected to the Impressionists' focus on light as lightweight, wanting to restore some rigorous aspects of earlier **painting**, such as careful construction of pictures based on rules of **composition**. One aspect of Impressionism that carried over was its attitude toward painting itself: the "footprint" of the brush (**brushstroke**) remained visible. The bright **colors** of Impressionism remained, too, but frequently they were used in unnaturalistic ways, such as when Vincent van Gogh and Paul Gauguin covered their canvases with thick, bright paint to infuse their **subjects** with something more profound or more searching than mere description. See also **Expressionism**, **Pointillism**, **Symbolism**.

Postmodernism

The diversification of **styles** and concerns that came with the waning of **modernism** as a style. Most postmodernism is a reaction to modern art, to some extent bouncing off it, often with humor. It is all over the stylistic map, including all **mediums** and running the gamut from **abstraction** to **pop**. The term "deconstructionist" is often used to describe postmodern art because so much of it rejects or subverts the ideas and **forms** of modernism, attempting to "de-construct" (debunk, or at least, debate) such attitudes as modern art's isolation from social concerns and its aesthetic goals of originality and purity. Postmodernists frequently borrow from earlier artists, including modernists, "appropriating" **subjects**, ideas, and styles, either out of respect or desire to make fun of them. In any case, artists appropriating from the past do so with awareness of what something originally meant as well as what it means taken out of **context**. Postmodernists tend to be sensitive to a wide range of **cultures** and issues

Mike and Doug Starn (American, b. 1961). *Stretched Christ*. 1985–86. Toned silver print, tape, wood, Plexiglas, 2′4″ x 11′10″ x 3′9″. Collection Stefan and Linda Stux

*An important feature of **postmodernism** is its unabashed recognition and appropriation of art of the past. Here, the Starn twins piece together images from photographs of a painting by the seventeenth-century Flemish artist Philippe de Champaigne, not simply creating a reproduction but also evoking one moment in time to serve another. The Starns update, not the crucifixion nor the resurrection of Christ, but his death—portraying a martyr killed for preaching his beliefs.*

Opposite:
David Wojnarowicz (American, 1954–1992). *Fear of Evolution*. 1988–89. Acrylic, collage, photographs on masonite, 42¹/₂ x 36¹/₂″. Courtesy P.P.O.W., New York

*Against a backdrop of United States currency, Wojnarowicz places a monkey in overalls and shirt carting a globe. Below, a double tornado twists across a bare landscape. The monkey might represent the notion of human evolution (hinted at by the title)—a theory that is violently rejected by many fundamental religions. The tornadoes suggest a quicker, more traumatic evolution, which, although literally deadly—unlike a theory— does not deter people from living in known danger zones. Like much **postmodern** art, this work's meaning is more poetic than logical and must be pieced together from imprecise clues.*

within them and are concerned with societal change, especially shifts in viewpoints. They tend to embrace changes brought about by civil-rights movements in general, including women's and gay and lesbian rights. AIDS is a preoccupation, along with sexuality, the human body, and new ways of seeing the self. See also **contemporary.**

Pre-

A prefix attached to a word to identify a **period** of art that comes before an important event, or before another significant **school** or **style**.

Pre-Columbian

Refers to the art of the highly sophisticated civilizations of Central and South **America** that existed before Christopher Columbus and the influences of Europe arrived beginning in the 1490s. Original (or indigenous) ethnic groups had **cultures** and dynasties that existed for hundreds, even thousands of years, controlling huge regions. After "discovery" by Europeans, they were admired less for their achievements than for their wealth, and as a consequence, the colonizers destroyed and/or exported a great deal of art, partly in an effort to replace the existing religions with Christianity. Grouping these cultures under one heading, however, minimizes their great diversity and accomplishments. A very brief sampling of the many Pre-Columbian civilizations is given below.

The *Aztecs* (1350–1521) dominated Central America at the time of the Spanish Conquest. They were highly developed in engineering, mathematics, astronomy, music, and picture writing. Their art included **ceramics, sculpture,** woven **textiles, carved** masks, metalwork, and **mural painting.** Tenochtitlán, the Aztec capital city and commercial and religious center, 30 miles northeast of Mexico City, is one of the largest and most impressive **architectural** sites of Pre-Columbian America. It is laid out in a grid dominated by the Pyramid of the Sun and the Temple of Quetzalcoatl.

The Castillo, Chichén Itzá, Yucatán, Mexico. Toltec-Maya, 1000–1200

Like those of the Aztecs and the Inkas, Maya civilization was characterized by sophisticated political, social, and economic systems and urban centers containing monumental architecture, much of whose originality was maintained even after conquest by the warrior Toltec nation. This merging of cultures and styles was common as the fortunes of various Pre-Columbian cultures rose and declined (see also the Mixtec-Aztec mask, p. 76).

Opposite:
Epignal mantle of tapestry weave with elaborate fringe. South coast of Peru. Early Wari, 700–900 CE. Cotton warps, woolen wefts, 43¹/₄ x 35⁵/₈″. The Brooklyn Museum. A. August Healy Fund and the Carll H. de Silver Fund

The Wari culture (600–1000) influenced artistic styles throughout Peru and Bolivia, carrying forward the rigidly hieratic, geometric representational tradition of the earlier Nazcas.

Located in the central highlands of Peru, the *Chavín* people were among the earliest known of Andean cultures. Active from 900 to 200 BCE, they were noted for their temples, painted sculptures, gold objects, and elaborate woven textiles.

Incorporating both the naturalistic tradition of the earlier Moche culture and the geometric patterning systems of the Wari, the art of the *Chimú* people dominated the north coast of Peru from around 1000 until the appearance of the Inkas in 1470. Chimú craftsmen excelled especially in the art of metalwork.

The *Inka* people flourished in the southern highlands of Peru from around 1400 to 1534. They made advances in stone architecture and city planning (including roads, bridges, and ferries) and developed a sophisticated farming technique for use in previously unfarmable terrain. One of their best-preserved sites is the city of Machu Picchu. The Inka are also remembered for their superior woodwork, polished ceramics (see p. 91), and complex metalwork.

The *Maya* dominated Mexico and Central America from about 250 BCE to 1000 CE. The Maya are often remembered for developing a sophisticated calendar. Numerous remaining Maya sites, including those at Palenque, Uxmal, and Tikal, also give evidence of their pyramids and palaces as well as beautiful multicolored ceramics and wall paintings.

The *Moche*, active on the northern coast of Peru for the first 700 years of this century, were noted for their dramatic ceramic containers depicting human figures or heads, ritual objects such as houses, as well as pots illustrating scenes of sacrifice or warning. Moche containers generally have handles that are as much a part of the whole as the images they portray.

Active on the southern coast of Peru at around the same time as the Moche, the *Nazca* people produced enormous animal drawings carved into the earth and thought to be related to their belief system and their study of astronomy. They were also known for multicolored pottery and textiles.

Predating and strongly influencing the Maya culture, the *Olmecs* (1200–600 BCE) of Mexico and Central America are remembered especially for their monumental stone sculptures as well as smaller carved jade objects.

The *Toltecs* (900–1200) of northern and central Mexico were early masters of architecture as well as other arts. Advanced workers of stone, they were also very skilled at melting and shaping metals.

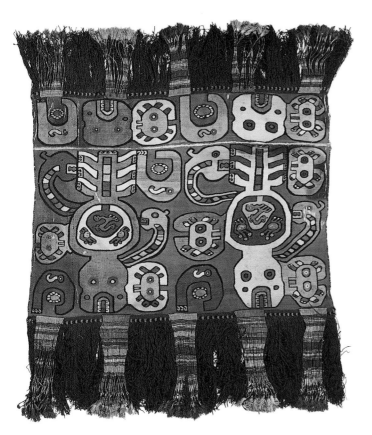

"Primitive"

The term "primitive" once referred to objects made by various non-European and **ancient** ethnic groups, which seemed "primitive" to the **Western** eye and mind when first seen in the late nineteenth century. Today the term is avoided.

Public Art

Art that is exhibited in public spaces. Sometimes it is commemorative (see **memorials**). At other times it is intended to beautify or enliven, often as an antidote to urban situations that are otherwise bleak—such as bland plazas, shopping centers, or subway stations. It is usually paid for by governmental bodies using public funds, and, since the 1980s, citizen groups have become more vocal about what art was purchased or commissioned with "their" money.

Qing

Established by the Manchus with the capture of Beijing in 1644 and enduring until the Revolution of 1911 led by Sun-Yat-sen, the Qing was the last of the imperial dynasties in China. The invading Manchus adopted many aspects of Chinese **culture**, and the arts—not only that influenced by the **Ming** dynasty but also a completely new and individualistic **style** exhibited in **ceramics**, jadework, and **painting** (see p. 130)—flourished. The poet/intellectuals called "literati" continued the long-held tradition of expressing their personal feelings through painting.

Realism

In its broadest sense, this term refers to techniques in art by which a recognizable **subject** is depicted with accuracy, or "realistically." Different times have dictated different attitudes toward the degree of realism, however. For example, early **Greek** **sculptural** figures were realistic but **stylized**, while **classical** Greek figures were **idealized,** and Hellenistic Greek sculpture were quite lifelike and energetic. The **Roman** desire for likeness led to making portraits from actual castings of dead leaders' faces as well as **illusionistic paintings** called *trompe l'oeil*, which in French means "fooling the eye," a technique that has reappeared periodically throughout history.

Though essentially realistic, much early **Asian** and **Byzantine** art tended to generalize facial fea-

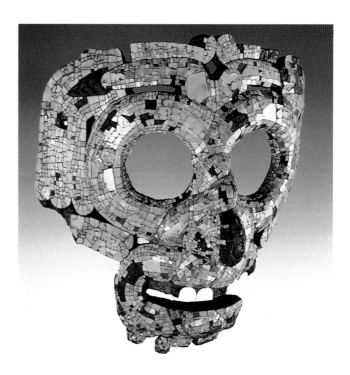

Mosaic mask. Mixtec-Aztec, 1350–1521. Turquoise mosaic with shell teeth on cedar base, height 7¹/₂″. The British Museum, London

Opposite, above:
Piero della Francesca (Italian, 1420–1492). *The Legend of the True Cross (Sheba Worships the Wood and The Meeting of Solomon and Sheba)*. 1452–66. Fresco, 11¹¹/₄″ x 19′6″. San Francesco, Arezzo, Italy

*The art of the **Renaissance** was still dominated by Christian subjects, although the clothing and buildings reflect the fifteenth century and the people themselves seem more identifiably human. The columns are an indication of the Renaissance respect for earlier classical traditions.*

Opposite, below:
Rosa Bonheur (French, 1822–1899). *Plowing in the Nivernais*. 1849. Oil on canvas, 5′9″ x 8′8″. Musée d'Orsay, Paris

*This painting represents two aspects of the nineteenth-century **Realist** movement. One is the "true-to-life" way it is painted, the other, that the subject matter depicts the hard reality of life among those who labor.*

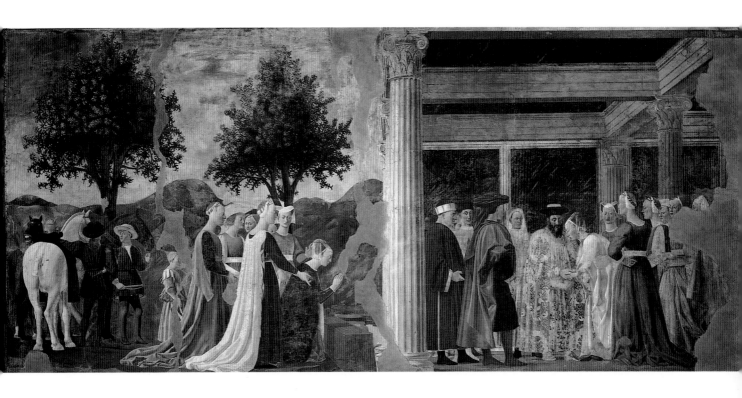

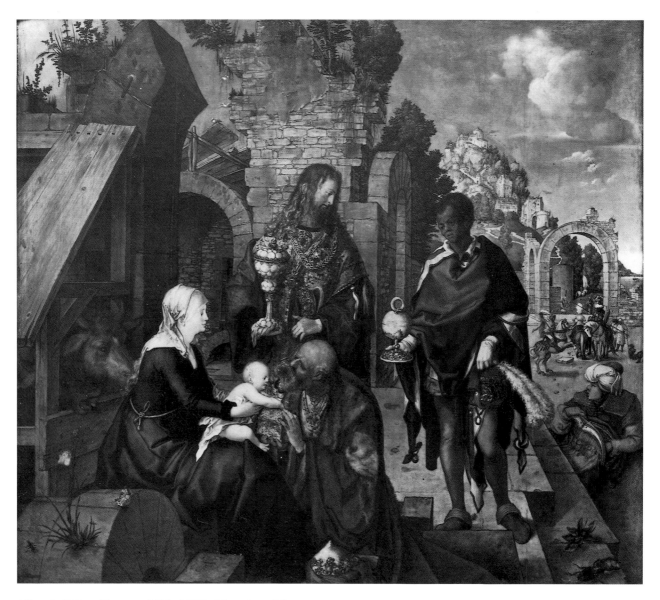

Albrecht Dürer (German, 1471–1528). *Adoration of the Magi.* 1504. panel 37⁵/₈ x 44⁷/₈", Uffizi, Florence

*Around 1500, **Renaissance** ideas spread from Italy northward to Germany. Although the art of the Northern Renaissance was not as coherent stylistically, increased drama and movement as well as humanizing of religious subjects—compare the light and dark areas as well as the setting of this painting with those of the Piero della Francesca (p. 77)—distinguish the style of northerners such as Dürer.*

tures, making people identifiable from gestures or garments. From the beginning of the **Renaissance**, it became a goal in Europe to make art as if one were looking through a window. The **rendering** of **space**, distance, **scale**, and **materials** was meant to be as we experience them in reality. Related to this type of realism is the term "naturalism," referring to the tendency of some artists to include the literal aspects of reality, even the mundane, such as a model's dirty fingernails or tattered clothing. For example, even though he depicted mythological characters, the seventeenth-century Italian artist Caravaggio often displayed this kind of highly detailed naturalism.

The **Impressionists'** concept of realism was to paint what the eye actually sees: reflected light. To paint most realistically was to capture the light. **Abstract** artists tended to think of all art as representation, not actuality, and therefore the way to be most realistic was to look to **materials** (such as **paint**), **colors**, **forms**, and marks left by the painter's tools as the "real" truths of art.

The invention of the camera probably contributed to a decreasing interest in realistic painting, until it emerged that **photography** created its own sense of reality—a narrow field of focus (something our eye seldom perceives), for example, or the washed-out quality of light from flashbulbs. At that point, trying to capture "photorealism" became a subject of painting—attempting to paint in the way that a camera records, not how our eyes function or what our minds say is logical.

"Super- or Hyperrealism" refers to an extension of **Pop Art** during the 1970s, when the use of certain kinds of painting techniques, such as the "air brush" developed for painting signs, made it possible to banish any brush mark or other sign of the artist's hand. Paintings could be made to have a slick, almost mechanical finish. The subjects chosen tended to be slices of ordinary experience, but in spite of their familiarity, they often seemed *too* real, almost to the point of **surrealism**.

In another important use of the term, realism can refer to painting (or writing) about one's own experiences or those of people at work and/or involved in everyday life, particularly one of hardship. This is most notably evidenced by the Realist movement of nineteenth-century Europe and echoed in the "Social Realism" of the the 1930s and 1940s in post-Depression United States, as well as its Socialist counterparts in the former communist nations.

Renaissance

A French word meaning "rebirth," it is the name given to the period in European history, when the Middle Ages—at one time referred to as the "Dark Ages"—gave way to a "rebirth" of ideals derived from the civilizations of **ancient Greece** and **Rome**.

The Renaissance was actually a slow and evolving process beginning in the fourteenth and fifteenth centuries in Italy and moving northward until the late sixteenth century. A surge of new ideas about the Christian God, the world, knowledge—as well as the relationship of humans to each of these—could be seen in literature, art, architecture, and science. Change first appeared in Italy probably because it was at the center of trade routes that allowed broad contact with other cultures, economic strength and stability, support for scholarship, and patronage for the arts.

The Renaissance is marked by a new sense of the individual, what came to be known as "humanism." Visually, it produced many radical breaks from **medieval** representations of the world and people. As focus shifted from God to humankind, interest grew in **classical** models, in which humans were seen as the measure of most things. Returning to classical rules of proportion, Renaissance artists followed rigorous systems of composing pictures to make them **balanced**, **harmonious**, timeless, and **ideally** beautiful. They also developed various tools, such as different types of **perspective**, as part of their parallel ambition to create more perfect representation of the physical world.

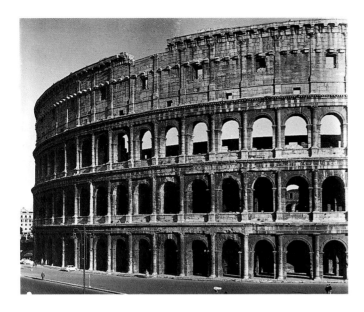

The Colosseum, Rome. c. 72–80 CE

The Roman arch made possible some of the largest, most expansive structures of the ancient world, as seen here in the Colosseum, the giant arena that today stands in partial ruins in the city of Rome.

Right:
Bearded Man (Lucius Junius Brutus). c. 300 CE. Bronze, height 12⅝". Palazzo dei Conservatori, Rome

The Roman interest in psychological realism can be seen in this bust, where wrinkles, slightly sagging skin, and a broad, sad mouth give us a sense of a person we might know, or want to know.

Rococo

An eighteenth-century **style** of **architecture**, **design**, and **painting** noted for its delicacy and elegance in response to what was perceived as the heavy boldness of **Baroque** art. Rococo art and objects are marked by elaborate shells and scrollwork as well as themes from nature, such as trees and flowers. See also **period**.

Roman

The art of the vast Roman Empire, dating from 30 BCE to the end of the fourth century, when the **Western** part of the divided and weakened empire declined in importance, making way for the rise of the **Byzantine** empire in the East. Though greatly influenced by the **Greeks**, Roman artists seemed less interested in **idealization** than in visual accura-

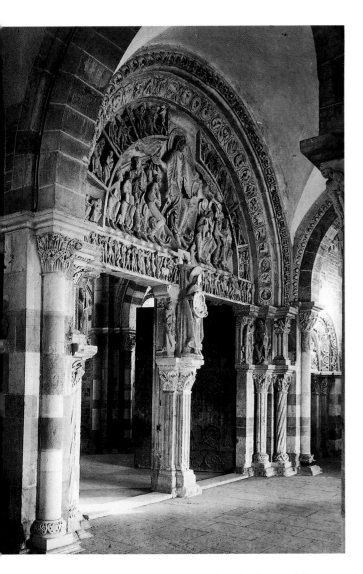

Central portal, Abbey Church, Church of La Madeleine, Vézelay, France. 1120–32. Carved stone

*Densely carved with relief sculptures of religious subjects, this entryway shows the huge rounded arches and thick supporting walls characteristic of **Romanesque** architecture.*

cy as well as psychological penetration. Roman art tended to serve the interests of government more than those of the gods, partly because the Roman emperors often set themselves up *as* gods.

As in Greece, a major Roman art form was **architecture**. Roman architects not only used the column to bear the weight of high ceilings but also invented a rounded arch, which, anchored in very thick masonry walls, made possible huge spans of open space as seen in the Colosseum and the vast domed areas of the great Roman baths buildings. Free-standing and **relief sculpture** on buildings depicted people and events, often triumphant battle scenes. **Portraits** of leaders were common, including "death masks," casts of faces of important figures created shortly after their deaths. What little **painting** that survives seems to have decorated houses of the wealthy (along with elaborate **mosaics**) and strived for the kind of **realism** so accurate that it makes us question whether we see a "real" scene or merely a painting.

Romanesque

A **period** in **medieval** art and **architecture** (roughly 1050–1200) inspired mainly by **Roman** architecture—especially the rounded arch—but which also included some elements of **Byzantine** design, particularly its tendency toward **abstracted** representations of **figures** and places. Wall **murals**, large-scale **sculptural** groups, and **illuminated manuscripts** were common. A huge and impressive body of **forged** metalwork also dates from this period.

Romanticism

An artistic revolt in the late eighteenth and nineteenth centuries against what artists believed was a confining emphasis on reason and order. The Romantics turned away from rigorous systems, mostly **classical** in origin, developed to insure rationality, and sought to represent spiritual concerns, such as humanity's innate goodness, or the truths to be found in nature. Experience, imagination, and the

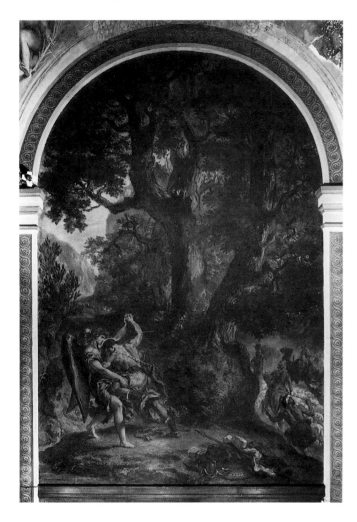

Eugène Delacroix (French, 1798–1863). *Jacob Wrestling with the Angel*. 1853–63. Oil-and-wax mural, 23′5¹/₂″ x 15′11″. Saint-Sulpice Church, Paris

*Defying a more standard composition, which would have focused the action at center stage with geometric systems such as linear perspective, the **Romantic** painter Delacroix directs our eye to a stagey, not-quite-believable fight in the lower left-hand corner.*

emotions were thought to be more important than intellect. Artists became fascinated and inspired by exotic and **"primitive"** cultures.

School

A term art historians used first to describe the students of a particular artist, or people who were strongly influenced by one but whose names were lost in history. A museum label will sometimes identify an unknown artist as "School of . . ." More recently, the term has been used to refer to groups of artists who work in a similar **style** or with similar attitudes, even if practitioners are known by name. The Hudson River School painters are linked because they painted within the same **period** (c. 1825–75) and because they all depicted the landscape, especially that of the Hudson River valley (see p. 138). The New York School was another name given to the Abstract Expressionists (see pp. 15, 58) of the mid-twentieth century.

Art schools are sometimes called "academies," and if the ideas of the teachers at an academy seem to influence strongly the art produced by the students, the work can be described as academic.

Song

A dynastic **period** in Chinese history (960–1279), during which **landscape painting** reached its peak. Following Confucian and Daoist principles, the magnificent landscapes featured small **figures** set within them. **Space** was indicated by placement, not **perspective**. Also during this time emerged the "monumental detail"—a single flower, tree, or bird as the **subject** of a painting—an aspect of **Asian** painting that has been very influential in **Western** culture. (See also illustration, p. 32.)

Surrealism

A movement in **modern** art announced in Paris in 1924 with a manifesto written by poet André Breton. Working in both **painting** and writing, especially, Surrealist artists believed that imagination

Vase, found in province of Chili, China. Northern Song dynasty, c. 1108 CE. Cizhou stoneware with sgraffito decoration added, height 12½". The Metropolitan Museum of Art, New York, Rogers Fund, 1925 (25.65)

*The aspect of Asian art perhaps most familiar to Westerners is beautiful ceramic ware, such as this **Song** mei ping (a vase designed to hold plum blossoms), whose decoration is achieved through a combination of painting and scratching into the surface.*

was most exciting and alive when it was the expression of unconscious, nonlogical sensations and inspirations. Some artists painted directly from dreams. Others tried to shut off any rational thought and make work that occurred by accident or was somehow led by the subconscious. Still others created "impossible" scenes by combining, in one image, objects or events that had nothing to do with each other. Much of their motivation came from new understandings about the mind and how it works, offered by the innovative thinking of various psychologists, such as Sigmund Freud.

Symbolism

A **school** of artists who at the end of the nineteenth century began to experiment with increasingly **abstract** ways of conveying ideas, often through distorted or exaggerated **figures** as well as **symbols**. They fixed on their inner selves as appropriate **subjects** for art and often depicted subjective, deeply personal understandings instead of describing exterior, physical realities.

Tang

China's great domestic and foreign strength during the Tang dynasty (618–907 CE) fostered a period of intense artistic exchange and a melding of **stylistic** influences from India (through the spread of **Buddhism**), as well as from central Asia and the Middle East. It was during this time that **traditions** in **landscape painting** began to be developed, reaching their peak in the **Song** dynasty.

Western

In art, the term has two meanings. The first is to describe art that comes from Europe and the **Americas**, thought by early European mapmakers—who did not believe that the world was round—to be west of **Asia**. It also refers to certain art of the western parts of the United States, meaning art that has to do with cowboys, pioneers, and European-American perceptions of **Native Americans.**

Joan Miró (Spanish, 1893–1983). *Birth of the World (Montroig)*. 1925. Oil on canvas, 8'2³/4" x 6'6³/4". The Museum of Modern Art, New York. Acquired through an anonymous fund, the Mr. and Mrs. Joseph Slifka and Armand G. Erpf Funds, and by gift of the artist

The background of this painting resulted from Miro's attempt to eliminate conscious control of his paint and brushes, a mode of operating developed by the **Surrealists**. *His own characteristic way of painting creature-like figures and shapes was then built up from the start given him by the subconscious.*

Opposite, above:
Paul Gauguin (French, 1848–1903). *The Day of the God (Mahana no Atua)*. 1894. Oil on canvas, 27³/8 x 35⁵/8". The Art Institute of Chicago, Helen Birch Bartlett Memorial Collection, 1926.198

The figures and forms of this scene are easily recognized as being from the idealized, unspoiled world the painter found in Tahiti, yet liberties are taken with physical reality in order to plumb more symbolic and spiritualistic truths as Gauguin saw them. Despite the bright colors, there is a stillness to this picture, and a deliberate, hieratical feel to the almost symmetrical placement of figures, which suggest the **Symbolists'** *visual approach.*

Opposite, below:
Altar, Cave 196, Dunhuang, Gansu, China. Tang dynasty, 8th century CE. Painted and gilded clay sculptures, dry fresco walls and ceiling

Preserved in this **Tang** *dynasty cave at an important Buddhist pilgrimage center is a complete altar arrangement combining elaborately ornamented ceramic figures and illusionistic wall and ceiling scenes painted on dry plaster.*

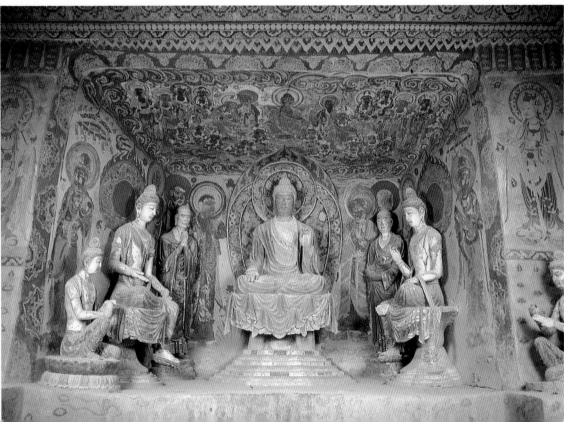

Mediums and Materials

This section defines a number of **forms** of artistic activity—such as printmaking and sculpture—as well as many of the methods and processes artists use to make art. **Medium** is the term used to distinguish one form from another, such as **painting, printmaking, sculpture**, or **architecture**. It includes both the working method (technique), for example **etching** or pen-and-ink **drawing**, *and* the **materials** that artists use, such as clay, stone, wood, and many kinds of **colored** pigment.

Medium also has another, more specific meaning, having to do with physical substances used in making art. For example, it can refer to the **oil** or **acrylic** into which pigments are mixed to make a certain kind of paint.

Typically, art of the twentieth century has complicated things. **Traditional** materials are often used in new and unorthodox ways, and materials never intended for art are adopted or adapted to serve artists' purposes. New technologies abound, offering a new array of mediums, including video and computers. Even the manner in which artists work can be difficult to understand. Part of the change results from the expanding knowledge of **cultures** around the world. What is conventional in one place is news to another, and exchanges of mediums—as well as ideas and styles—have become commonplace.

In art the common plural form for "medium" is made usually by adding an "s" to the word. The word "media" is used two ways, the first in reference to communication technologies, such as television, film, radio ("electronic media") and newspapers and magazines ("print media"). The term can also be used to describe forms of artistic activity that use several mediums, as in "mixed media."

Acrylic

Paint with a synthetic (not natural) base that dissolves in water and into which colored pigments are mixed. It can be used in many ways, but the resulting paint is both cheaper and in many ways easier to use than **oil**. Acrylic has a different texture from oil paint and produces a different surface as a result. It dries much more quickly, too. It is easier to use on large **canvases** because it spreads more easily. Acrylic is opaque, so that **colors** tend to be mixed by the artist before application; with oil paint, which is more transparent, layers of paint ("undercoats") are built up to create the final picture.

Architecture

While it might be used to refer to all structures, in art, architecture generally refers to buildings that are planned and **designed**, not simply built. At many points in history, architecture is the most prominent art form of a civilization—during **medieval** times, for example. The ambitions, beliefs, values, technical abilities, and wealth of a culture show up in architectural structures of many kinds, from pyramids to temples to great walls, each requiring huge commitments of resources. During much of **Western** history, other arts have been thought of as less significant. **Sculpture** was not meant to stand on its own but as an essential part of buildings. Before it ever made its way onto canvases, painting was done directly on walls. Most furniture was built according to the design principles that guided the creation of buildings.

Through architecture, we can trace the influences of one **period** or **style** on others. We can see how design ideas move from one place to another, and then to another. We can see how long the process takes, and how different ideas mix—or don't.

Court of the Lions, The
Alhambra, Granada,
Spain. Late 14th century
(fountain is 11th century)

*The Alhambra was the
palace of the Moorish kings
(expelled from Spain in
1492), which remains
today as testimony to the
Moors' brilliance as **archi-
tects** and the intricate
beauty of Islamic decora-
tive patterning.*

Robert Rauschenberg (American, b. 1925). *Monogram*. 1955–59. Oil, stuffed goat, tire, wood, canvas, and paper, 48$\frac{1}{16}$ x 72$\frac{1}{16}$". Moderna Museet, Stockholm

*Influenced by abstract art, Rauschenberg introduced subjects and objects from the real world into his work, but in a way not guided by logic. He was fascinated by **assembling** disparate materials and things—each with a meaning or use of its own. What they come to mean in combination is elusive, but somehow the presence of today's world filled with images always comes to mind. Think for the moment of a slow flip through television channels. We easily make sense, from quick glances, of passing images that have nothing to do with each other.*

Assemblage

The trend in **modern** art to assemble many different kinds of materials to create an artwork that usually becomes both **sculpture** and **painting**. Anything can be included—artistic materials, "ready-mades" (see **Dada**), recycled or industrial products, and even detritus and debris. One of the motives behind assemblage is the desire to reassess the precious nature of art and to expand the general definitions of what is right or acceptable. Compare with **collage**.

Bronze

A metal "alloy" (mixture) of copper, zinc, and tin, easily melted and **cast**, used in **sculpture** and building. When we speak of the **ancient** Bronze Age in history, we refer to a period around 3500 BCE, in which tools made of bronze were first used. See also **patina.**

Calligraphy

Comes from a Greek term meaning "beautiful writing" and refers to handwriting, usually done with special brushes or **pens** when practiced as a fine art. In **medieval** Europe, books were handwritten and great attention was paid to the lettering (see also **illuminated manuscripts**). Today in Japan and China, especially, the art of **painting** words and symbols continues to be prized.

Canvas

A tightly stretched cloth surface on which to **paint.** Many different fabrics can be used—linen and various grades of cotton, most commonly. Canvases are usually mounted on wooden frames called "stretchers" and are light and portable yet firm and strong enough to withstand the effort involved in painting and the weight of paint itself.

Torii Kiyonaga (Japanese, 1752–1815). *Shigeyuki Executing Calligraphy*. Edo period, 1783. Color woodblock print, 14³/₄ x 9⁵/₈". Philadelphia Museum of Art. Given by Mrs. John D. Rockefeller

This woodblock print not only displays varied examples of the art of **calligraphy** *but also shows the tools and a method of working.*

Canvases can be made in many sizes and **shapes**, although traditionally they are square or rectangular, used both horizontally or vertically. Smaller canvases are usually placed on **easels;** larger ones are often painted against a wall. In either case, the finished work is traditionally displayed within a frame. **Modern** artists (see also **abstraction**) often abandon or minimize the frame, thus asserting that the work is a thing in itself, neither a mirror of the world or a window onto it.

Prior to the regular use of canvas, painting in Europe was often done on wooden surfaces, referred to as "panels," as well as walls and ceilings (see also **triptych** and **mural**). Many **Asian** artists paint on silk, usually mounted on another surface, not stretched.

Carving

A **form** created by cutting into stone (such as marble or jade), wood, ivory, or other material. The process itself is also called carving and is a way of creating **decorative** objects and **sculptural reliefs** as well as objects with religious and/or magical powers.

Casting

The process in which an object is created by pouring a liquid substance—such as molten metals or still-wet plaster—into a **mold,** letting it harden, then removing it from the mold. One way of casting, called the "lost-wax" method, involves making an object, for example an earring or a **figure,** in wax, then encasing it in a material—such as plaster—that hardens, leaving two openings. Hot metal is poured into one opening, melting the wax, which drains out through the other opening. Once the metal has hardened, the casing is broken away to reveal the cast object.

Ceramics

Word used to describe objects—bowls, vases, plates—as well as **sculpture**, made out of soft clay dug from

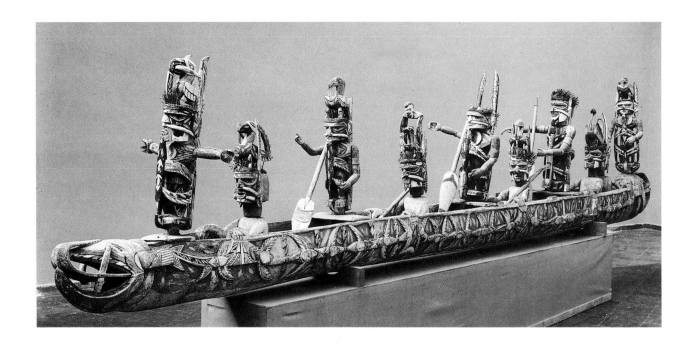

"Soul Boat." New Ireland. c. 1903. Carved wood, length
19'. Linden-Museum, Stuttgart, Germany

*Carving in wood can range from whittling to the making of
huge, elaborate pieces such as this one from New Ireland in
the South Pacific. The meaning of this Oceanic work is
uncertain, since most "soul boats," usually representing a
dead chieftain and his relatives, were actually sent to sea in
imitation of the rite performed for the human counterparts.*

Right:
Donatello (Italian, 1386–1466). *Equestrian Monument of
Gattamelata*, Piazza del Santo, Padua. 1445–50. Bronze,
c. 11 x 13'

*This Italian Renaissance sculpture, cast in the metal alloy
bronze, is another form of memorial art.*

the earth and then specially treated to harden them. Particularly in **ancient** cultures, sacred objects and those used in special ceremonies were made from clay. The term is now used to include a wide range of simple and complex technologies (both hand-**crafted** and machine made), types of clay, and functions. Most types of ceramics involve forming an object in soft clay, then baking ("firing") it in special ovens ("kilns"), causing it to change composition and therefore harden. After an initial firing, ceramic objects can be decorated by a method of coloring on the surface, called "glazing." They are then refired to adhere ("bond") the glazes to the surfaces. Not only can this make an object more beautiful but also more durable and resistant to staining or leaking.

"Terra-cotta" is a type of ceramic made from clay fired at temperatures high enough to make it insoluble (yet still porous) and hard enough to be used in building floors, roofs, and wall tiles. Terracotta has a characteristic brownish-orange color, and, because of its durability, has been used to

"Whistling" vessels. Peru. Inka, c. 1470–1532. Ceramic, average height approximately 6". Private collection

The Inkas' most innovative contributions to the decorative arts centered on utilitarian objects, such as these **ceramic** *containers, which are prized for their technical perfection as well as their beauty.*

make many sacred objects. "Porcelain" is made from a fine white clay and fired at very high temperatures, allowing it to be formed into objects thin enough to be translucent. Often beautifully and brightly glazed, porcelain is often referred to as "china" because that is where porcelain ware was first made. "Soft-paste" china is fired at lower temperatures than those of "hard-paste" china, or true porcelain.

"Earthenware" is pottery made from a particular kind of clay; it is similar to terra-cotta in that it is fired at relatively low temperatures. A popular type of earthenware, called "faience," incorporates opaque, brightly colored glazes made from tin. "Stoneware" is ceramic, usually light in color, which, like porcelain, is fired at very high temperatures.

Charcoal

A substance obtained from slowly burning wood, stopping before it turns to ash, charcoal is fragile to hold and very light. It easily makes marks on surfaces, from light to dark gray, depending on how hard it is pressed. A sharp edge can produce a thin **line**. A blunt point or a broad side can fill in a whole area quickly.

Charcoal is usually applied to paper and is soft enough to let the **texture** and **color** of the paper show through. It is particularly useful for making large, sketchy **drawings**, a bit awkward for small or detailed ones. It can be smeared or erased easily unless given a protective coating.

Collage

A two-dimensional form of **assemblage** made by gluing pieces of paper, wood, cloth, or other materials to a flat surface. The artist expresses a vision or an idea by arranging a **composition** of these different kinds of materials into a single picture. Because the materials incorporated usually had a recognizable purpose originally, they still remind the viewer of that association, making it possible to complicate a picture's meanings.

Costumes

Outfits made for a **performance** or event, usually transforming or disguising the wearer. They range in function from **decorative**, as in Japanese "kimonos," to ritualistic, as used in Native American and African ceremony, for example. Costume can also refer to the outfit worn by someone depicted in a work of art. In museums, a collection of clothing will be called a costume collection.

Craft

An artist's working process or skill, craft is often associated with handwork and relatively simple tools and technology, as in **drawing** with a **pen** or **painting** with brushes. It is also used to refer to particular **forms** of artistic activity (called "crafts"), such as working with clay, wood, and fiber, each of which can be handled in many ways, with finishes ranging from roughly **textured** to highly refined. In crafts such as **enameling**, jewelry-making, and stitchery, both techniques and tools are often highly specialized. As with **folk** art, the existence of craft as a category for certain art-making activities tends to suggest it is different from "fine art," a distinction today considered simplistic or unimportant by many.

Decorative arts

Various kinds of useful objects that are made with the intent to beautify and to improve the visual quality of life. Decorative arts are found in all kinds of materials—from wood, **ceramics,** and metals (precious and otherwise) to plaster, paper, and plastic—and include **patterned designs** on many kinds of surfaces, such as floor coverings and other **textiles**; furniture and **architectural** details; china, stained **glass**, and silverware. In many cases—with much

Georges Seurat (French, 1859–1891). *Seated Boy with Straw Hat*. 1882. Conté crayon on paper, 9¹/₂ x 12¹/₄″. Yale University Art Gallery, New Haven. University Purchase, Everett V. Meeks; 01 Fund

*Using a conté crayon (a hard, grease-free **drawing** tool) on roughly textured paper allowed Seurat to mold the form of a boy using no lines. Shading results from the density of the crayon, with highlights appearing from what little of the paper is allowed to show through, an effect similar to that which can be achieved with charcoal.*

jewelry, for example, as in a queen's crown—decorative objects are intended to indicate the owners' wealth and/or position in society.

Design

The overall visual presentation of an artwork, including both **composition** and **style**. It can also refer to the aspects of a work that do not represent particular people or things, in the sense of **patterns** of colors or lines. A design can refer to a drawing, or even a model, as in the preliminary layout or plan

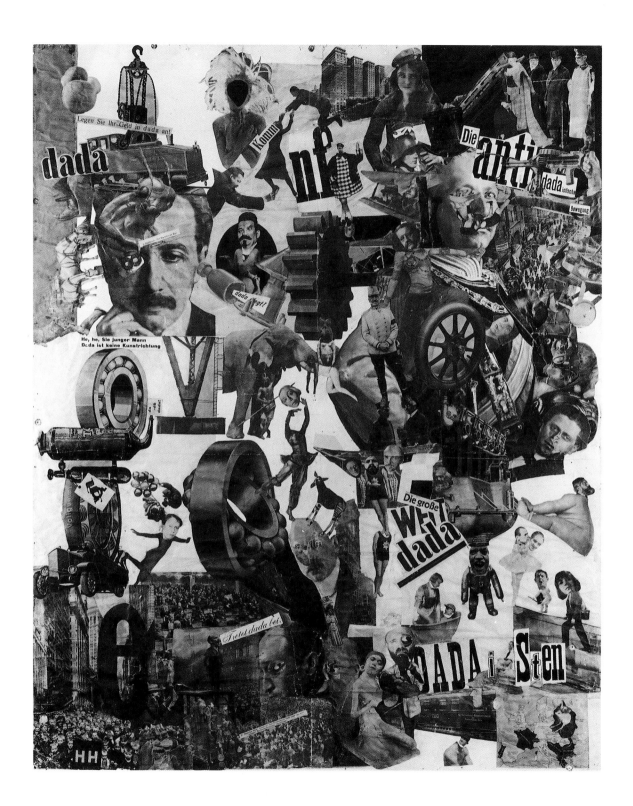

Michelangelo Buonarroti (Italian, 1475–1564). *Studies for the Libyan Sibyl*. 16th century. Red chalk, 11³/₈ x 8³/₈". The Metropolitan Museum of Art, New York. Purchase, 1924, Joseph Pulitzer Bequest (24.197.2 obverse)

*This red-chalk **drawing** by the Renaissance master Michelangelo includes quick "sketches" of poses and body parts, done as preparatory "studies" for part of his enormous fresco on the ceiling of the Sistine Chapel in the Vatican, Rome.*

Opposite:
Hannah Höch (German, 1889–1978). *Cut with the Kitchen Knife*. 1919. Collage, 44⁷/₈ x 35³/₈". Staatliche Museen zu Berlin—Preussischer Kulturbesitz, Nationalgalerie

*The tumbling, nonsensical sense of the world of Dada is spelled out and given visual form in this **collage**.*

of a painting or sculpture, on the basis of which the eventual piece is executed. It can also be used to describe the process of planning something—as in designing a building, dress, or stage set. "Graphic design" is the term applied to the arranging of images and printed texts, as in laying out a magazine or book. "Industrial design" refers to the activity of coming up with ideas and plans for all sorts of manufactured products. The source of such design through much of **Western architectural** history has been books containing drawings of existing buildings, often containing the designs of decorative details, called "pattern" books.

Drawing

An important medium of artmaking that involves putting marks or **lines** on some surface, usually paper. Many different materials can be used (see **charcoal**, **collage**, **pastel**, **pen and ink**, **pencil**, and **watercolor**). Drawing is often a way for artists to train their hands to describe what they see more accurately or more expressively. The act of drawing includes "sketching"—a loose, quick **rendering** of some object, person, or even an idea, sometimes done simply to "warm up." It can also refer to carefully preparing a "study"—a slower process that may involve visible changes of mind, redrawn lines, and even erasures; there can be several studies on a page, usually of some facet of the same subject—working out the drawing of a hand, for example. A drawing can also be a plan or layout (**design**) for another work, such as a painting. Some of these are referred to as "cartoons," gridded outline drawings of figures and objects used to guide the creation of large works such as tapestries or murals. Often artists draw directly on canvas, maybe using paint, as an additional stage in envisioning and thinking through an image. The process of making groups of drawings can help an artist "think out loud," developing an idea or exploring new ways of working.

For viewers, drawings can provide insight into the steps involved in creating, particularly into how

Tosa Mitsuoki (Japanese, 1617–1691). *Maple Leaves with Poem Slips*. Edo period, c. 1664–78. Six-fold screen: ink, colors, gold leaf, and powdered gold on silk, 4′8¹/₈″ x 9′7¹/₂″. The Art Institute of Chicago; Kate S. Buckingham Fund, 1977.157

*A common form in Japanese **decorative arts** is the folding screen, which can be used to section off parts of a room. This screen features a tree covered with poems painted in calligraphy.*

changes evolve. While drawings traditionally have been seen merely as stepping stones in a process, and therefore secondary to painting or sculpture, in recent times they have come to be appreciated as fresh, intimate works of art on their own.

Easel

The stand on which a **canvas** rests when an artist is **painting** or **drawing**. "Easel painting" refers to paintings of a scale (i.e., fairly small) to fit on an easel.

Enamel

Made from some of the same elements as **glass**, enamel is applied in its molten state to another surface, usually metal, and heated to bind them together. When cooled, enamel forms a hard coat and has a wide range of bright **colors** and finishes. It is a

popular **decorative** element in jewelry and other small objects. One common form of enameling is called "cloisonné," which involves soldering thin metal strips (*cloisons*) onto another metal surface in a **pattern** and filling in the spaces with enamel. Another technique—"champlevé"—differs slightly: the metal surface is hollowed out and enamel poured in to fill the hollows (see illustration below).

Stavelot Triptych of the True Cross (commissioned by Abbot Wibald). c. 1155. Interior enamels: Byzantine cloisonné; larger rondelles: Western champlevé enamels, copper gilt, and silver; jeweled and enameled frame, 19 x 26" (fully opened). The Pierpont Morgan Library, New York

Gustav Vigeland (Norwegian, 1869–1943). Gate to Vigeland Park, Oslo, Norway. Made 1927–38, mounted 1941–42. Wrought iron, height (with lanterns) c. 32'

*This monumental gate was made of iron wrought by **forging**.*

Opposite:
Giotto (Italian, 1267?–1336/7). *Lamentation*. After 1305. Fresco, Arena Chapel, Padua

*The Italian painter Giotto created beautifully colored **frescoes** of Christian religious scenes on the walls of churches during the very early Renaissance. Here, Mary, the mother of Christ, and other family members and followers mourn his death.*

René Lalique (French, 1860–1945). *Suzanne*. 1925. Molded opalescent and stained-glass statuette, height 9¹/₁₆″. Collection Victor Arwas, London

*This molded-**glass** sculpture is an example of the Art Deco style in decorative arts.*

Forging

A process of **shaping** metal by heating it to very high temperatures and then hammering it into a desired **form**. Wrought iron is forged, for example. Compare with **welding** or **casting**.

Fresco

A technique of **painting** water-based pigments directly onto a wet plaster wall, more or less as one would apply paint to a canvas. The image becomes part of the wall's permanent surface. Such paintings are referred to as frescoes.

Glass

A hard substance created when minerals found in sand and chemicals are melted at high temperatures, formed into objects, and then cooled. Glass hardens as it cools and keeps the **form** it was given. The surface can be cut into or "etched" with acid to create **decorative patterns**. Forms can be **cast** using **molds**, and fine-quality glass can be "blown" into desired forms by picking up the still-hot liquid on the end of a long tube and blowing air into it. "Stained" glass is often used to decorate windows (see p. 46), lampshades, and vases.

Gouache

Paint created by mixing water directly into powdered pigment. Unlike regular **watercolor**, which is transparent, gouache is "opaque"—the paint forms a solid surface when it dries, obscuring anything beneath it (see illustration above).

Illuminated manuscript

As early as the second century, but especially from the twelfth to fifteenth century, "manuscripts" (texts written by hand) were generally created on "parchment"—animal skins stretched very thin and prepared with special solutions—the primary writing surface in Europe before the introduction of

Jacob Lawrence (American, b. 1917). *Harlem Series No. 8—The Children Go to School*. 1943. Gouache on paper, 14 x 21". Private collection, courtesy of the artist and Francine Seders Gallery, Seattle, Washington

Opposite:
Virgin and Child, page from *The Book of Kells*, Ms. 58, fol. 7v. Late 8th century. Illuminated manuscript, 13 x 9¹/₂". Courtesy The Board of Trinity College, Dublin

The Book of Kells *was found in a monastery in a tiny town in northeastern Ireland, where monasteries were centers of culture and learning. This* **illuminated manuscript** *of the Christian gospels also contains notes on local history.*

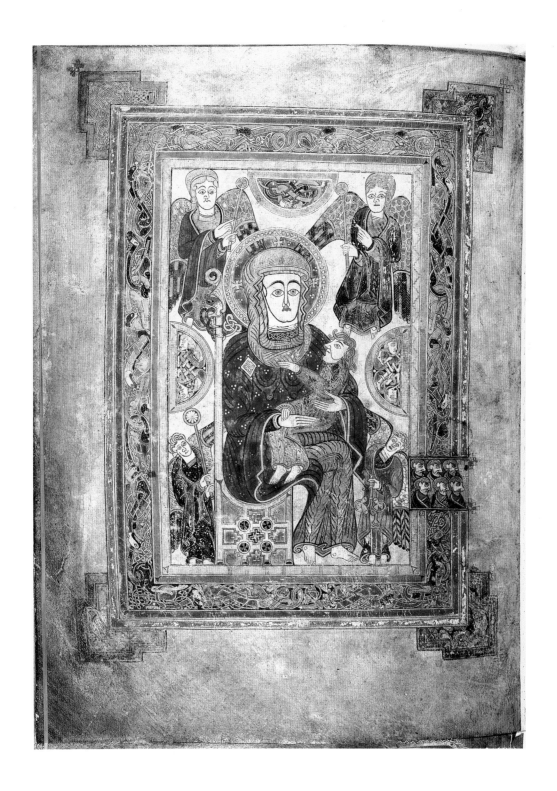

paper there in the twelfth century. They were illustrated with colorful **tempera** and gold paints, the pages decorated in margins and around the first letters of the texts. The term "illumination" reflects the bright and luminous quality of these pages. The **subjects** were usually religious in some way. In some cases they commemorated seasons, festivals, or the piety and devotion of the manuscripts' owners.

Molding

The act of manipulating a soft **material** in order to create an object, such as forming a lump of clay into a head. Molding can also refer to raised-plaster **decorations** on ceilings as well as wood panels that divide a wall surface into sections. A "mold" is a form in which soft or molten materials can be placed and left to harden, to produce objects such as **cast sculpture** and **glass** or **ceramic** objects that might be needed in large quantities.

Mosaic

Pattern or image of many-**colored** pieces of stone (often marble), **glass**, or tile (called "tesserae") adhered to a flat surface. In **ancient** times, mosaic floors decorated the homes of the wealthy; during the **Byzantine** era, mosaics were used for religious imagery, especially wall and ceiling **murals**.

Mural

From the French word for "wall," a mural is a painting created for walls or ceilings. Known at least as early as **Egyptian** times, murals can be found both in- and outside buildings. A **fresco** is a kind of mural, for example. In the twentieth century, murals most often have a social message and are a common means of expression in Mexico and the southwestern United States.

Oil

A **paint** made from mixing pigments into an oil base. It can be made in different degrees of thick-

Alberto Giacometti (Swiss, 1901–1966). *Walking Man II.* 1947–48. Cast bronze, 26$^{1}/_{2}$ x 11$^{1}/_{2}$ x 5″. Hirshhorn Museum and Sculpture Garden, Smithsonian Institution, Washington, D.C., Gift of Joseph H. Hirshhorn, 1966

This sculpture is an example of a work made from creating a **mold** *and casting the figure we see from it. Giacometti's spindly, aimless, often anonymous figures seem to sum up the feeling of living in Europe in the aftermath of two devastating world wars.*

Charles W. Felix + VNE Cobras (American, b.d. unknown). *The Sacrifice Wall.* Estrada Court, East Los Angeles. 1974. Day-Glo paints

*This **mural**, painted by members of a neighborhood youth gang, is based on a Pre-Columbian relief sculpture in Veracruz, Mexico.*

Blessing Christ, from the Deëis mosaic, Hagia Sophia, Istanbul. 13th century

*This Byzantine **mosaic** has been partially destroyed over time, and patches are missing from the left and along the lower edges of the image. Shown here is a portion of a mosaic "cycle" of scenes conveying a larger story.*

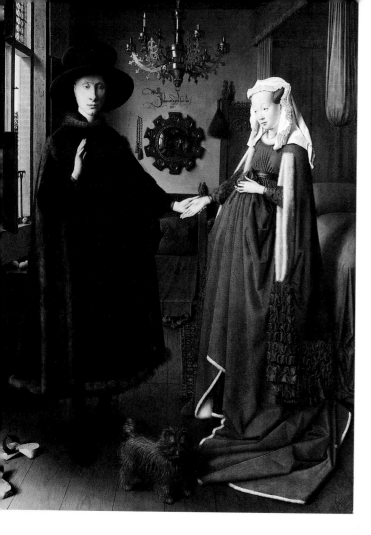

Jan van Eyck (Flemish, c. 1390–1441). *Arnolfini Wedding Portrait*. 1434. Oil on panel, 33 x 22½". The National Gallery, London

Although **oil** *varnishes can be traced to the time of Alexander the Great, Jan van Eyck was among the first to develop oil's potential, creating detailed scenes and optical effects that closely resemble the physical world, in his case usually applied to evoke the spiritual one.*

Opposite:
Mary Cassatt (American, 1845–1926). *Sleepy Baby*. c. 1910. Pastel on paper, 25½ x 20½". Dallas Museum of Art, Munger Fund

One effect that can be obtained from **pastels** *is the light sketchiness of this gentle drawing of a mother and child by Impressionist artist Mary Cassatt, an American who lived and worked much of her life in Paris.*

Right:
Norman Rockwell (American, 1894–1978). *Triple Self-Portrait* (cover illustration for *The Saturday Evening Post*). 1960. Oil on canvas, 44½ x 43³/₁₆". Norman Rockwell Museum at Stockbridge, Massachusetts

This self-portrait shows Rockwell at work, surrounded by reproductions of self-portraits by past artists as well as by tools of the **painting** *trade: brushes, a tube of paint (on the floor), the artist's* **palette** *and* **easel***, and a drawing with study sketches clipped to the upper left of his* **canvas***.*

mary Cassatt

ness ("viscosity") allowing different **textures** to be created. Oil dries slowly, so that gradations of a **color** can be mixed and mistakes can be wiped away or even scraped or sanded off later. It is often protected from dirt and fading by a coat of clear varnish. Unlike **acrylic**, which is opaque, one oil color can be painted over another once the earlier has dried somewhat, and some of the original color will show through. Fifteenth-century artists were leaders in experimenting with oil-based paint. It is still preferred by many painters.

Painting

A way of making a picture by applying a sticky liquid mixed with **colored** pigments to paper, panel, or **canvas** when it is wet and allowing it to dry. The liquid "binder," or "vehicle," is usually **oil**, water, or a synthetic substance. Paint is most often applied with a brush, but other tools, such as a sponge, "**palette** knife," or even fingers can be used.

Palette

A piece of wood or a tray on which to lay out small amounts of **paint**, the palette allows the artist to choose **colors** and to mix and test them before they are applied to the painting surface. The artist mixes the colors with a "palette knife," which can also be used to apply paint and to create impressions or designs in the paint once it is there.

When discussing art, the term "palette" refers to the range of colors an artist uses in a particular work, such as different **shades** of blue or an array of darker colors.

Pastel

A soft, chalky **drawing** material that can be used in many of the same ways as **charcoal** but has the advantage of coming in **colors**. If pressed heavily, the colors can be laid down with considerable **density**, producing a slightly **textured**, flaky surface and bright colors. Often, however, pastels are used with a light touch that produces sketchy marks and pale colors, and the word has come to be associated with pale blues, greens, pinks, and yellows.

Pen and ink

A tool for writing or **drawing** and the liquid substance—usually black in color—that is applied by the pen to a surface. Pens have existed for centuries, from quill pens made from large feathers and dipped into pots of ink to today's felt tips. An advantage of this kind of drawing is that one can make thin, dark **contours**, and **modern** artists in particular have found the spare simplicity of this appealing. The preferred method of making darker and lighter areas—shadows, for example—in ink drawings is by **hatching** and **crosshatching**. Ink can also be applied with a brush (as in **calligraphy**), usually thinned with water, making it easier to cover large areas of a surface with few strokes and no resulting lines, much like **watercolor**. This process is called "wash" drawing.

Pencil

A writing and **drawing** tool, usually made of wood surrounding a graphite core. It produces **lines** varying from light to dark and thin to heavy, depending on its hardness or softness.

Performance

Literally a work of art, a piece of theater, dance, or music performed in front of a live audience. Beginning with **Dada**, however, and in particular from the 1960s onward, some artists challenged notions of what was interesting to perform; for example, instead of carefully rehearsing known theatrical **forms** in order to meet or exceed audience expectations, they emphasized spontaneity, chance, and the unpredictable. In much the same way that **modern** painters asked viewers to seek meanings in **abstraction**—trying to expand notions of what we look for and learn from in **painting**—artists in the performing areas experimented with both **content** and form. Performers, many with little training, came to be

Gertrude Käsebier (American, 1854–1934). *Road to Rome.*
1903. Platinum print, 9¹/₄ x 13¹/₄". The Museum of Modern
Art, New York. Gift of Mrs. Hermine M. Turner

*In many ways, the camera can be used as painting and draw-
ing have been traditionally. Käsebier was one of the pioneers
in composing **photographs** whose choice of subjects and
point of view, as well as patterns of light and darks and lines
and textures, convinced others that the camera was a signifi-
cant artistic tool, not simply a technological achievement.*

seen as sources of fresh ideas and ways. New instruments were invented, old ones used in new ways. Dance, theater, music, and the visual arts experimented with crossing boundaries. "Performance artists," as they came to be known, made very personal presentations, combining elements of all arts, often using film and video and including outrageous images and behavior and absurd elements.

Photography

A means by which chemically sensitized surfaces are exposed to light ("photo") and retain an **image** ("graph") of what is in front of them. The methods by which this is done range from very simple to highly complex. At present, they usually involve cameras that have carefully calibrated and controlled openings ("apertures") to let in light; fixed and adjustable lenses to select and maintain a **plane**, or point of focus; and split-second timers in order to let in just enough light to capture an image on light-sensitive film—which, after exposure, is chemically processed ("developed") to keep ("fix") the image permanently. This image (a "negative") is usually transferred onto treated papers, enlarged, and processed with chemicals in a lab called a "darkroom," making what is known as a "photographic **print**." (In this instance, no press is used in the process of transferring an image from film to negative to the final paper.)

When we speak of photography, we are usually talking about "still" images, not "moving pictures," although they use related equipment and systems. We have only understood how to capture an image on paper through a chemical process since the early nineteenth century. The earliest still photographs were called "daguerreotypes." They were made by a Frenchman, L. J. M. Daguerre, who produced his images on silver plates that had been treated with iodine.

It is sometimes difficult to see photography as an art form because it is used in so many other circumstances—from illustrating newspaper stories; assisting many forms of science, industry, and advertising; to documenting events of our personal lives. Artists who use photography often capture images—natural or human made—that others miss. They might focus on people or objects in unusual ways, catching them at a particularly interesting moment or from a surprising point of view. Viewers must look not only for what is in the photograph—its **subject**—but also at the artist's **craft**, or technique—how he or she frames, composes, captures, and prints a picture. We can begin to understand an artist's intentions by examining his or her literal **viewpoint**, by looking carefully at the angle, the light, how close or far away from the subject the artist was standing, and so forth.

Artists can combine photography with other arts, such as **printmaking**, to create, for example, "photoengravings" or "photosilkscreens."

Pictogram

Writing that uses pictures—usually simplified drawings from nature and human activity—to represent a word, syllable, or sound. Much **ancient** writing, for example **Egyptian** "hieroglyphs," was based on such symbols, and various **Asian** languages still are. "Petroglyph" is another name given to picture writing, usually reserved for paintings on cave or cliff walls; there remain many examples in the southwestern United States, records of the presence of **Native Americans** long before the arrival of Europeans.

Primer

Before beginning to **paint**, artists prepare their **canvases** with a liquid or smooth paste called "primer." "Gesso" is one common primer. When dry, it creates a firm, smooth, consistent surface on which to paint. The paint will adhere properly to the primer and maintain its original **color**. Paint dries in unexpected ways on "unprimed" canvas. The resulting surprises have been of great interest to some **modern** artists.

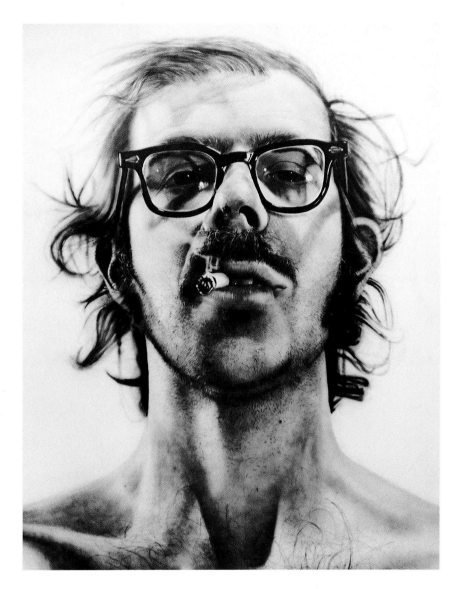

Chuck Close (American, b. 1940). *Big Self-Portrait.* 1968.
Acrylic on canvas, 8'11½" x 6'11½". Collection Walker Art
Center, Minneapolis. Art Center Acquisition Fund, 1969

*Chuck Close takes **photographs** of his subjects—in this case him-
self—and then greatly enlarges them, making paintings that main-
tain the characteristics of snapshots: minute detail, the washed-out
light that comes from the use of flash (complete with the bulb's
reflection in Close's glasses), and narrow range of focus. At one
point in history, photographers tried to imitate painters; now it is a
two-way street.*

Rafael Tufiño (American, b. 1922). *Cane Cutter (Cortador de Caña).* 1951–52. Linocut on paper, 11½ x 18½". Museum of History, Anthropology, and Art of the University of Puerto Rico

*The strong, dark lines possible with relief **prints** help to focus the rhythmic motion of the sugar-cane harvester into a circular pattern, the center of which is the figure's hat.*

Printmaking

Art made by transferring an **image** from an original source to another surface, usually paper. Most forms of printmaking involve a press by which one applies pressure to a metal plate, stone, or block, allowing the transfer of the image ("impression") to the second surface. Printmaking is a way for artists to make multiples of an image; in other words, many images can be "struck" from the original source, creating what is known as an "edition," a set of identical prints that are numbered and signed by the artist. The artist will create the image in the first place, but the rest of the process is often collaborative. In such cases, the artist works with specially trained printers to arrive at an image that has the desired look—referred to as an "artist's proof." There might be several such proofs to guide the printers in creating exact replicas of the desired effect. The eventual size of the edition (number of prints) depends on several things, including the varying capacity of the source to remain crisp and true.

One of the difficult aspects of printmaking is that, aside from those areas of a print that are **colored** by the paper showing through, each different color comes either from the creation of a separate plate or from colors "mixing" when one is laid over another. The artist can create a print, produce an edition, and then decide to make changes, and a second edition—or more—can result; these are referred to as different "states."

There are many different printmaking methods. In one of the earliest, the image is arrived at by carving into a surface. The primary example of this is a "woodblock print" where the artist cuts pieces of wood away, leaving an image or design upraised or "in **relief**." The raised surface is "inked," and, when pressed against paper, the ink transfers, leaving an impression. The press is needed to insure even and complete transfer of the ink. As in most prints, the impression will be the mirror image of the **design**—what is on the left of the carved surface will be on the right of the impression. This is important if direction is a concern, such as when letters or numbers are included in a print. A more recent "relief print" technique is "linocut" (or linoleum print), made from carving into the soft side of linoleum blocks specially made for this purpose. One visual characteristic of relief prints is their strongly contrasting dark and light areas and powerful, often thick **lines** and **shapes**. During the **modern** era, especially, the grain and imperfections of the wood might be incorporated into a woodblock image.

Another print technique is "engraving," in which an image is cut into the surface of a wooden or metal plate with a tool called a "burin." In a way, engraving might be seen as the opposite of relief printing: instead of the desired image being raised above the rest of the plate, it is sunk into it. The "incised" areas (the cuts or scratches) are filled with ink, while the raised surfaces are kept clean. The plate is then run through a printing press, which exerts enough pressure to squeeze paper into the tiny lines, transferring the inked image. The pressure is so great that marks from the plate's edges usually remain impressed into the paper and are visible to the eye.

A well-known form of engraving is "etching," where a metal plate is coated with resin or wax, and, using a sharp point ("stylus"), the artist carefully draws an image into the coating, scraping some of it away and leaving the metal exposed. The plate is then placed in acid, which eats into ("etches") the exposed parts, most frequently constructed of lines, such as **contours** and **hatching**, although "stippling" (making dots to create shapes and forms) is also used. The plate is removed from the acid frequently so that the artist can keep track of the depth of the etching. The deeper and wider the acid cuts, the stronger the eventual mark. If some lines seem deep enough but others do not, the artist can coat the finished parts of the plate and return it

Opposite:
Robert Indiana (American, b. 1928).
LOVE. 1966. Serigraph, 32 x 24″.
The Museum of Modern Art, New
York. Gift of Posters Originals, Ltd

*Often used in the 1960s, to make eye-catching posters, the **printmaking** technique of serigraphy was selected by Indiana to create this icon of the Love Generation.*

Above right:
Katsushika Hokusai (Japanese, 1760–1849). *South Wind and Clearing Weather*, from the series Thirty-Six Views of Fuji. Edo period, c. 1823–29. Woodblock print, 9⅝ x 14″. The Metropolitan Museum of Art, New York. Rogers Fund, 1914 (JP 9)

*Applying color in large areas is easily possible with relief **printing**, and lines can be made delicate as well as bold. Compare this image with that of Tufiño on p. 110 to get a sense of how differently lines can read in relief printing.*

Below right:
Francisco Goya (Spanish, 1746–1828). *Precise Folly (Disparate Puntual— Una Reina Del Circo)*, from *Proverbios*), printed 1864. Etching and aquatint, 9⅝ x 13¼″. Courtesy of the Hispanic Society of America, New York

*Goya used the **printmaking** techniques of etching and aquatint, both forms of engraving, to make this dense image of a circus performer. Note the detail of the crowd almost hidden in the hatched lines behind the horse.*

to the acid. When the image is ready, the entire coating is removed. The plate is inked, filling only the etched indentations, and run through a press. A visual characteristic of etchings is their dependence on lines, many of them very thin and delicate, to define the image. "Aquatints," "mezzotints," and "drypoint" are variations on this theme, and each has some distinguishing factor making it interesting to artists. For example, in drypoint a stylus but no acid is used to incise the image. Aquatints and mezzotints allow greater variations in density, areas of tone, and texture to give a more **painterly** effect.

A third major type is the "offset" (or "planographic") print, of which the "lithograph," developed in 1796, is the best known example. In this case, the artist makes a drawing (remember that the image must be drawn in reverse, or backward) on a very smooth limestone surface. When the drawing is finished, the stone is wet with water. The crayon used to make this drawing contains a kind of grease; water will not stick to it but lithographic ink will. The ink is in turn repelled by the wet parts of the stone. The ink will transfer to paper when run through a press. Today this process is done with metal plates more often than stones. The look of lithographs is varied; in fact the medium is the most flexible of any printmaking **medium**. In lithography, **lines** as well as **planes** can be created with virtually the same range as in **drawing**; even **photographic** images can be transferred to the stones.

A fourth common print technique is the "serigraph," or "silkscreen." In this instance a press is not used, which makes it an easier, cheaper process than others; a stencil is created by applying a special resin to block out parts of finely woven silk stretched tightly within a frame. The image, often created with photographic technology, results from using a tool very much like a window-cleaning squeegee to squeeze ink through the open (un-blocked) mesh of the silk onto the paper beneath. Although easily scratched, the surface of a screen print is very densely colored and tends to be brighter than most prints. The size of the image is not limited by presses or stones, so they can easily be very large. With silkscreens, the transfer does not reverse the image; therefore it is easy to use where text is included. It is frequently used to print on cloth, including T-shirts.

A "monoprint" is an image that can be reproduced exactly only once. Most often the image is painted in oil paint onto a sheet of metal or glass and then transferred to paper with the aid of a press. Most of the paint transfers with this first "pull." Sometimes additional prints might be attempted, and they are called "ghosts." Another way to make monoprints is to use a traditional technology to create an image that an artist then hand colors, or otherwise draws or paints on freehand to create a unique image.

The suffix "-type," as in monotype or linotype, is used interchangeably with "-print." In prints that are made through the process of carving in relief, the suffix "cut" can be substituted for "print," as in woodcut.

Relief

A form of **sculpture** that is not fully **three-dimensional**. For example, reliefs might protrude from the surface of a stone building. Reliefs traditionally are **carved** or **cast** and can be in "low" ("bas") relief, as in the profile of a figure on a coin or as used in some **printmaking**. They can also be in "high" relief, meaning that they have greater physical depth. Reliefs are often illustrative or commemorative, depicting religious scenes as well as people and events from history. Most historic site markers are low reliefs; many **architectural** "friezes"—contained spaces above doorways or within the triangular space created by a peaked roof—are in high relief.

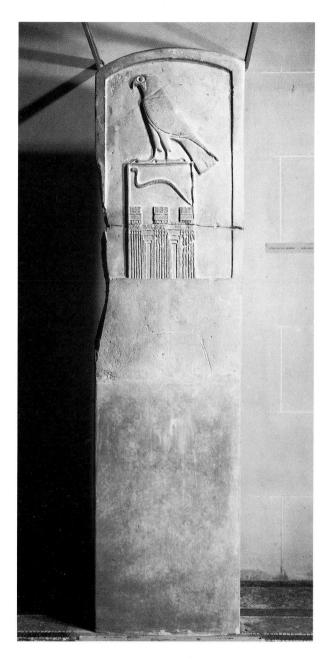

Stele of Djet, found Abydos, Egypt. c. 3000 BCE. Lime-stone, height 21⅝". Musée du Louvre, Paris

*A "stele" is an upright slab or pillar, usually carved in **relief**, used as a monument, often a funeral marker.*

Rendering

The way an artist uses his or her tools to **draw**. For example, a sketch may be "rendered" in bold, rough strokes of pencil or charcoal. A pen or brush may be used very meticulously to render an object in great detail, and so forth. The rendering of a work is closely tied to its **style**, the way it looks.

Reproductions

Reproductions refer to exactly what we would expect: mechanically made copies of something, as in a photographic reproduction of a painting—not to be confused or used interchangeably with a **print**, which is an original work of art. Sometimes reproductions are done in exact facsimile, usually identified as such: the **Romans** so admired **Greek** sculpture that they commissioned many **classical** copies. "Copying" is a time-honored practice of learning to paint from trying to re-create works by great artists. When a facsimile reproduction is passed off as real, it is called a "forgery" or "fake."

Sculpture

The art of **carving**, **casting**, **forging**, **molding,** or **welding** material such as stone, wood, clay, or various metals into statues or other objects. Many sculptures are built around a structure called an "armature," which—much in the way a skeleton works—supports the weight and shape of the finished work. Much early sculpture was religious, and much of it through time has been created as part of some **architectural** setting. Some of the earliest sculptures we know of were created by the Sumerians, who lived in present-day Iraq more than five thousand years ago. One frequent sculptural form is the **figure**, including "busts," which are only the head and shoulders of humans. Much sculpture is commemorative. See also **memorials**, **public art**, and **relief**.

Tempera

A form of **watercolor paint** made from mixing colored pigment into a sticky base—earlier in history egg yolks were used; today the substance is usually a kind of glue—that will adhere to a surface such as paper. Although it is relatively inexpensive, tempera makes subtle color effects difficult to control because it dries quickly and permanently. Tempera was often used in early **medieval** paintings on wood panels; today, because it is water soluble and easy to clean up after, a form of it, called "poster paint," is a popular choice for use by young people.

Textiles

Materials created by spinning fibers into thread or yarn and weaving, knitting, or otherwise combining them to create what we also call "cloth"—ranging from simple and rugged "homespun" to delicate laces. Textiles can be made of natural fibers such as cotton, wool, or silk, or synthetics such as nylon and polyester. Linen, a textile made from flax, was discovered in the ruins of ancient **Egypt**, dating from 5000 BCE. **Asian** artisans have long been admired for elegant and complex silks. Rugs from the Middle East, woven by different means and richly patterned, are highly prized. Native peoples throughout the **Western** Hemisphere have woven and embroidered for thousands of years. The Paracas culture of **Pre-Columbian** Peru, for example, has left us spectacular weavings dating from around 300 CE. Most ethnic groups and **folk** cultures have identifiable **styles** of making cloth and clothing, ranging from Navaho blankets to Persian rugs.

Textiles are created both for practical purposes, such as clothing or bedding, or for decorative and ceremonial reasons. Costly and intricate fabrics—studded, for example, with jewels; sewn with beads; interwoven with precious metals; or combined with furs—can be made into **costumes**, dazzling displays of wealth, position, and power. A very complicated form of weaving, called "tapestry," was especially

Eyedazzler. North America. Navajo, c. 1890. Wool blanket, 74$\frac{1}{2}$ x 54$\frac{1}{4}$". Field Museum of Natural History, Chicago

*The weaving of colorful blankets and other **textiles** with striking geometric patterns and various symbols is a traditional art of the Navajos living in the American Southwest.*

Opposite:
Vanity or *Sight*, from the series Lady with the Unicorn. 15th century. Tapestry, 10'2" x 10'10". Musée Cluny, Paris

*A **textile** that was particularly popular from the eleventh to the fifteenth century in Europe, tapestries were woven on huge upright looms, behind which were cartoons, or drawings, that the weavers followed. Tapestries covered the walls of noble dwellings for decor (and heat retention as well), illustrating real and allegorical scenes of courtly life.*

Nam June Paik (Korean, b. 1932). *Video Flag Z*. 1985.
Moving painting: 84 color Quasar television sets, three
video-disc players, eight electric fans, three video discs
by Nam June Paik, Plexiglas mounting cabinet, fan-
mounting assembly, and supporting base structure; third
in edition of three. The Los Angeles County Museum of
Art, Gift of the Art Museum Council

*One of the first artists to embrace **video** as an artistic medi-
um, Paik not only experiments with imagery on the screen
but also makes sculpture and installations using multiple
television monitors.*

popular as early as **medieval** times. Huge tapestries were created to illustrate stories and myths, serving much the same purpose as paintings; they were more versatile, however, helping a high-ceilinged, stone room retain heat in winter.

Triptych

A work of art divided into three parts, as the prefix "tri-" would indicate. The triptych form was used a great deal in **medieval** times to make elaborate "altarpieces" consisting of a large central panel and two side panels that could be folded in over the larger one to protect the sacred images contained within. Installed in churches, the altarpieces might be opened only on special holy days. Similarly, a "diptych" has two parts, usually equal in size. Both forms were also used to create small, portable altars.

Video

The use of television technology to produce art; most of it is somehow reactive to commercial presentations. For example, because of the ease and portability of video equipment, forms of documentaries can be made, often differing from what one sees on networks, both in terms of what is discussed and how it is depicted; just as painting can be **abstract**, the content of video art can be nonlogical and poetic. Video artists often work with technology before it is available to the public and were among the first to apply computers to experiment with visual effects. Instead of always presenting their work in the format of programs on tape, video artists often work with multiple monitors in **installations**, in circumstances that use the form in combination with other **mediums**, and in ways that let the viewer interact with the technology—to become active in the process of completing the artwork.

Watercolor

Paint often associated with **drawing**. Colored pigments are mixed with a substance that allows them to dissolve in water, and they are usually painted on paper. The paint itself can be so dense as to appear opaque against the paper (see **gouache** and **tempera**), but the look normally associated with watercolor is obtained by keeping the paint thin and allowing the paper to show through. Since watercolor paper is often white, it is the paper itself that creates the lighter areas within a painting.

Welding

A means of combining metal elements by heating the edges of two pieces (at the "join") and fusing them to each other with additional molten metal. When cooled, the bond can be enormously strong. This has greatly increased the capacity of artists to build very large works. It also makes it easier to create works with **asymmetrical** balances, as we can see in much **abstract, modern sculpture**.

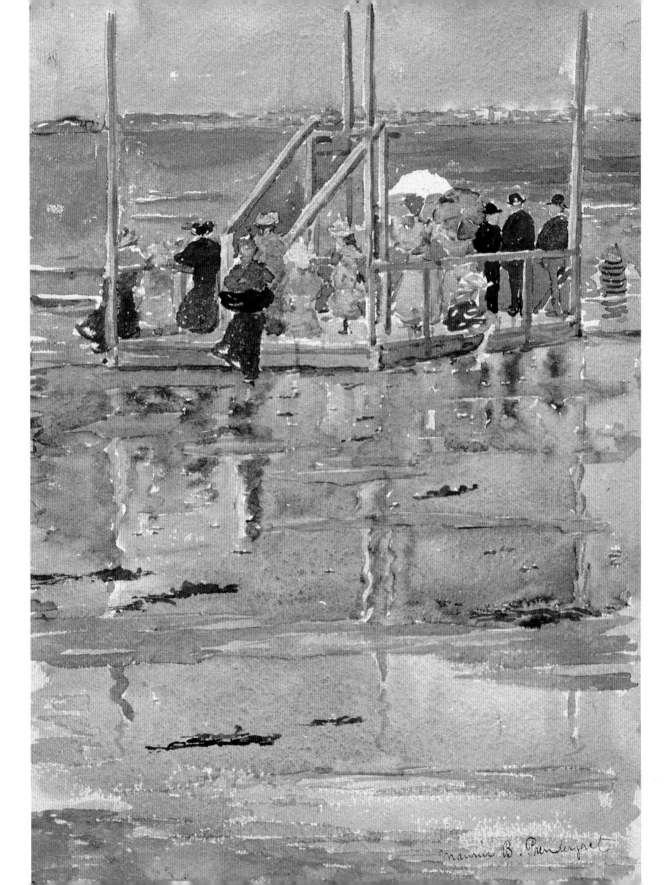

Maurice B. Prendergast

David Smith (American, 1906–1965). *Cubi XII*. 1963.
Stainless steel, 9'1½" x 4'1" x 2'2". The Hirshhorn
Museum and Sculpture Garden, Smithsonian Institution,
Washington, D.C., Gift of the Joseph H. Hirshhorn
Foundation, 1972

Opposite:
Maurice Prendergast (American, 1859–1924). *Float at Low
Tide—Revere Beach*. 1898. Watercolor on paper, 13½ x
9½". Addison Gallery of American Art, Philips Academy,
Andover, Massachusetts. Gift of Mrs. W. C. Endicott

*Prendergast let the white of the paper show through the
watercolor to achieve a quality of shimmering reflected light.*

Isamu Noguchi (American, 1904–1988). *Noh Musician*.
1958–74. Stainless steel, 76 x 34 x 11⅝". Pace Gallery,
New York

Welding *makes it possible to join metal in such ways as to
defy gravity and create the asymmetrical balances that
intrigued sculptor David Smith. Isamu Noguchi cut and
hammered steel to open up space and create a varied surface.
The effect is quite different from Smith's, especially in terms
of its sense of stability.*

Breaking Art Down: Analytical Language

Understanding a work of art takes time and effort. It involves a number of steps, one of which is coming to some personal interpretation of an object's meanings. Another involves gathering information to enrich and extend what we can figure out on our own. It is interesting to learn, for example, what an artist intended to communicate or what an image/object might have meant to the people for whom it was first made.

Yet another—the one this chapter addresses—focuses on a process of pulling a work apart, in the way we might scan a poem, dissect a worm, or inspect the insides of a mechanical toy. As with these examples, it is not something we do naturally until motivated to find out what makes something tick. Called "analysis," it probably developed alongside scientific methods to provide an objective way of studying art. We do it by "dissecting" a work with our eyes and our reason. We carefully examine each separate element—the **colors**, say, or the sense of **space**—and then try to determine how it interacts with other elements, and finally how it influences the whole. How does the artist convey a sense of space? Is the space logical? Is it consistent? Does the use of color reinforce, or contradict, that sense? What do both contribute to the overall impression? More than being an end in itself, analysis is one way to figure out the "rules" of a certain **style**, or just how artists convince us to believe what we see.

Albrecht Dürer (German, 1471–1528). *Draftsman Drawing a Woman*, from *Demonstration of Perspective*, 15). 1525. Woodcut

*Among the Renaissance **compositional** tools that particularly fascinated Dürer was **perspective**. Here he shows an artist using a see-through grid to help him establish the perspective in his drawing. Notice also how light and dark areas are created in this woodcut: the density of darkness is achieved by the closeness of **hatched** and **crosshatched** lines.*

Analyzing what we see in front of us is particularly helpful when looking at **modern** art, much of which has no naturalistic image or **subject**. A modern artist often takes what would have been one aspect of a picture—like the geometry underlying its **composition**—and makes it the entire focus. Meaning comes from the sense that can be made of the interactions of colors, **lines**, **shapes,** or **brush-strokes**. Through much of the past, artists paid attention to such elements only as tools to increase the naturalness of the things they depicted. In the modern era, artists came to believe that these elements contained messages of their own. What is the impact of an orderly series of precise shapes versus a mass of swirling lines, they asked, or dark, murky colors versus bright, lively ones?

As before in this book, some terms have more than one meaning in discussions about art, and all are mentioned within a single entry.

COLOR

We know that shining sunlight through a prism breaks it into a rainbow of colors, called the "color spectrum." Three primary, or pure, colors—red, blue, and yellow—combine to create all other, "secondary" and "complementary," colors in the spectrum.

We see color because certain natural elements—called "pigments" when isolated—reflect light in particular ways. Color helps vary and beautify both nature and art. It is also functional in both: using color, we can distinguish certain things from others, though their shapes may be alike. Artists use color to correspond to nature (making grass green, for example) or to contradict it. In the first case, they are trying to remind us of the "real" world; in the second they are most likely imagining and inventing. Dim light sources such as the moon make it hard for us to read colors accurately.

Sometimes artists use stark contrasts in colors to create a sense of energy or motion. Color oppo-

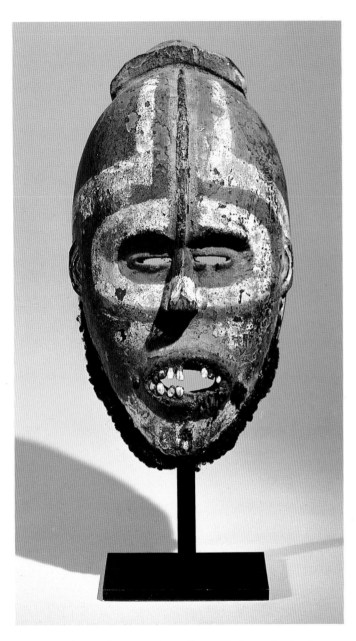

Mask. Southwestern Ivory Coast. Undetermined culture. Wood, human hair, dim. unknown. Private collection

Color is a factor in most art, be it the radiant gold of an icon, the splashy brightness of a Fauve painting, or the startling markings of the African mask above.

sites (red and green, for example) will appear to vibrate in our eyes when they are next to each other; think of the contrasting colors used to enliven holiday decorations. Conversely, artists can use similar colors ("tonal equivalents") to make a picture calm.

Strictly speaking, white is not a color; it results from a surface on which there is no pigment for light to reflect off of. Black results from a surface absorbing all the colors in the spectrum.

Cool
Some colors remind us of things that are cold—as in icy grays or soothing blues. These colors are called "cool." Any **hue** may be made cooler by adding white.

Density
When color is applied to surface, it can be in a manner that is light, sketchy, and even transparent, or it can be with such intensity as to appear solid or opaque. This quality is referred to as its density. To say something about density is to remark on the quantity of light that seems to emerge from the color.

Hue
A more specific or technical way of referring to the name of a given color. For example, blue is a hue.

Patina
The coloration of the surface of **sculpture**. Patinas are often the product of aging and weathering—the way that **bronze** or copper turn green-blue, or Cor-Ten steel rusts, or a stone statue can take on a mottled look from lichen or moss. Some artists create patinas intentionally, usually as an attempt to control the look of a piece as it ages rather than leaving things to chance. In the **modern** world, artists may in fact want to keep mother nature at bay and/or avoid the effects of dirt and pollution.

124

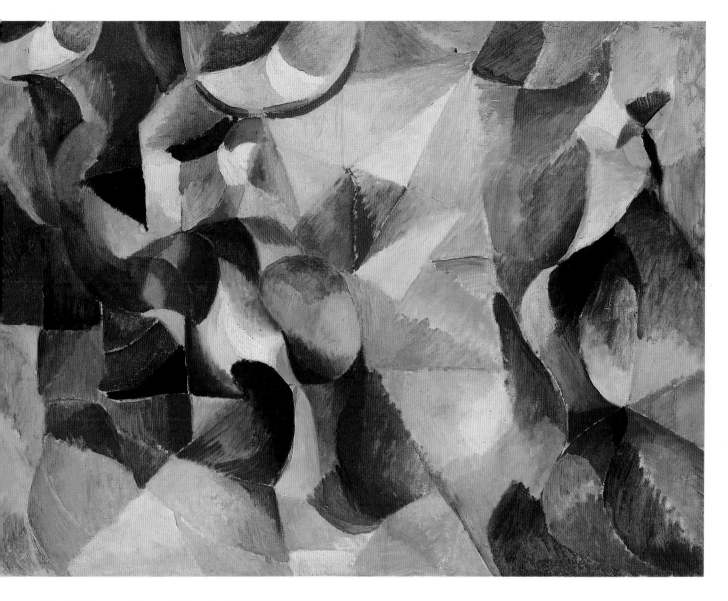

Sonia Delaunay (French, b. Russia, 1885–1979). *Le Bal
Bullier*. 1913. Oil on canvas, 38¹/₈ x 52″. Kunsthalle
Bielefeld

*Often in abstract art, arrangements of **color** are treated as
subjects. Paintings like this one are "about" the effect of one
color on another—of subtle changes in **tone** and **density**, for
example—and the relationship of colors to shapes, or parts to
the whole.*

Shade

When black is added to a hue (e.g., blue) to make it darker, the resulting color is referred to as a shade (e.g., navy or midnight blue).

Tint

When white is added to a hue to make it lighter, the resulting color is referred to as a tint (e.g., light blue). In music, a hue might be a pitch; shades and tints might be that pitch played at different volumes or by different instruments.

Tone

One of many terms used to describe aspects of both art, especially **painting**, and music. In both cases, it has to do with the quality of the impression—how gentle or harsh it appears, for example. Artists create tones primarily by choosing among many colors as well as painting a range of **shades** and **tints** of a single color. They can paint in colors that blend easily ("tonal equivalents" or "similar tonalities"), or they can choose to make sharp contrasts. Or they can do both, of course.

Warm

Some colors remind us of things that are hot—as in the reds we associate with fire. This capacity is referred to as "warmth." The colors that are considered warm are derived from red and yellow even when they are muted, as in the earth tones. Darkening a hue tends to make it warmer.

LINE

Lines begin as dots and can go off in any direction: straight, curving, broken, thick/thin, dark/light. Some lines are created by an artist making a mark with an implement such as a **pen**, a piece of **charcoal** or chalk, or a **pencil**. Other lines are only implied—lines that occur, for example, from seeing several trees in a row. In works of art, several objects in alignment can suggest a line moving in a certain direction (see **perspective**), as can several points of the same color—a series of highlights, for example. An uplifted arm can create a curved line, as it is seen to do in ballet as well. On the flat surface of a canvas, the points along which two blocks of color or two **shapes** meet creates a line. The edges of a **canvas** or piece of paper can be seen as lines against which to define all others in the **composition**.

Contour

The outline or outer edge ("silhouette") of some **shape** or **form**. The contours of a sculpture are rounded and soft if depicting a human form or sharp if describing a geometric shape.

Hatching, crosshatching

A series of parallel lines used especially in **drawings** and **prints** as a method of darkening areas—to make shadows, for example. The closer together the "hatched" lines, the less the white of the original surface shows through and the greater the impression of darkness. Lines can also be "crosshatched"; that is, two or more sets of parallel lines are laid over each other in offset grids, their **density** producing considerable darkness at a distance.

Linear

Those aspects of art having to do with lines. Linear can also refer to the quality of having many and obvious lines, such as those found in Byzantine art.

Shape

The outline of some mass. Shapes can be *recognizable* objects, animals, or people; *geometric* (circles, squares, triangles, etc.), or **abstract** (organic, lyrical, or suggestive). See also **contour**, **form**, and **volume**.

COMPOSITION

The arrangement of elements in a work of art—more or less comparable to a skeleton—essential to

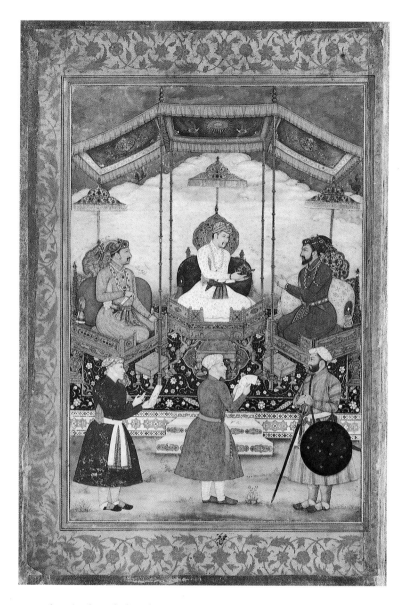

Bichitr (Indian, b.d. unknown). *Akbar Hands His Imperial Crown to Shah Jahan* (page from the *Minto Album*). Mughal dynasty, 1631. Miniature. Reproduced by kind permission of the Trustees of the Chester Beatty Library, Dublin

*Although marking a particular event in the history of the Mughal empire in India, this image contains a richness of **patterning** reminiscent of much Islamic art and decoration. It was under Mughal rule that a distinctive style of Indo-Islamic art and architecture developed in India.*

Piet Mondrian (Dutch, 1872–1944). *Broadway Boogie Woogie*. 1942–43. Oil on canavs, 50 x 50″. The Museum of Modern Art, New York. Given anonymously

the structure but invisible. The composition is the organizing principle or plan of work, although it comes intuitively to many artists. The **lines** and **patterns** of a composition can lead our eyes toward what the artist wants us to notice; it can create a sense of motion and activity or stability and calm. In some **modern** art, as in the work of the Dutch artist Piet Mondrian (opposite), a harmonious composition is the major focus of the work.

Balance

To understand how balance is used in art, imagine a seesaw. When two riders are the same size, shape, and weight, the seesaw pivots them up and down easily. Under these circumstances, the seesaw can even be brought to balance in midair. If a photograph were taken at that point, seesaw squarely centered in the picture, the image would be said to be balanced and completely **symmetrical**—both halves identical.

If the picture were taken of two riders who weighed the same but one was short and stout and the other long and lean, the image would be **asymmetrical**—the two halves would not be identical in shape and arrangement. The two halves of the picture might still be considered balanced, however, and in that case the term "**dynamic** equilibrium" is likely to be applied.

This notion of balance is fairly easy to work out as long as we are dealing with **lines** and **shapes** easily seen in relationship to one another. It becomes more ambiguous when the elements are **colors**. How much white does it take to balance black? Red and orange? This is a major issue in abstract painting, where the vigor of a **gesture** can also affect balance. In all cases, achieving balance—however tenuous—is one of the most important aspects of composing a work of art.

Dynamism

Seeming to have energy or force; the aspects of pictures that seem to be in motion. For example, a ship can seem to be tossed about by a tempestuous sea, wind blowing furiously. Such movement is not really happening, but its **illusion** is created in part by **subjects** that call to mind vigorous action. The subject is reinforced by less obvious means, such as use of **lines** and angles to suggest a direction of force and/or by applying thick paint using obvious **brushstrokes**, signs of action in themselves.

Harmony

A term borrowed from music to suggest a satisfactory or pleasant arrangement of elements.

Pattern

Repetition of **shapes** within a work, usually a matter of **lines** and **colors**. Sometimes patterns are the essence of a work, such as in **Islamic** art; at other times, they are implied. The word is sometimes used to mean **design**, a plan for making something—a dress pattern, for example, or the pattern of **molding** in a ceiling.

Symmetry, Asymmetry

Symmetry is an arrangement of parts so that the **shapes**, **patterns,** and **colors** are identical on either side of a central boundary, the two halves of a work mirroring each other exactly. Asymmetry is an arrangement of parts so that the opposite sides, divided by a center line, are not identical.

Viewpoint, or vantage point

The point from which the artist seems to have been looking in order to depict a scene. With **portraits** and **landscapes**, we are likely to find ourselves viewing the image from the same point as the artist. Paintings on ceilings often use various distortions to make us feel as if we are looking up at a much higher distance than we are. Because of the portability of cameras, strange, hard-to-determine viewpoints are common in art **photography**.

Sculpture makes a great deal of viewpoints. An artist may position a piece to affect how we see

it—up on a high pedestal, for example, or at eye level. Free-standing sculpture also allows the viewer to move around and see a work from many angles and distances—or viewpoints.

SPACE

Among the **illusions** that particularly interest artists are ones that can make our eyes perceive space when in fact we know an artwork to be flat. If we are to believe a picture's reality, we must "see" the air that we would expect outside, or that a bowl sits on a table with fruit inside, behind, and in front of it. This sense of space is achieved by a number of devices. A primary one is the placement of things in logical relationships to one another. For example, objects that overlap will appear sequential within a space. Objects depicted above others will be seen as behind them, and vice-versa. Another convention is to pay attention to **scale**—making a house larger than an apple on the same **plane**, for example, or an apple close to the foreground bigger than one farther away. Objects in the distance are likely to appear small and fuzzy, as if harder to see. The interactions of **colors**—darks tending to recede from the viewer, lights to move toward them—is also useful in creating the illusion of logical space.

Beginning in the **Renaissance**, **Western** artists often sought to create believable illusions of space and followed certain rules fairly carefully. Often **Asian** artists employed a different system of rules in depicting space and depth. And many **modern** artists broke the rules in order to confound expectations: some created believable space, then violated it within a single picture (see the use of color in Matisse's *Interior with Girl Reading*, p. 2). Some abandoned spatial illusions in favor of flatness—the literal truth of paper and canvas (see Picasso's *Man with a Pipe*, p. 36). Others concerned themselves only with the interactions of **colors** and planes (see Mondrian's *Broadway Boogie Woogie*, p. 128). See also **form** and **volume**.

Wang Jian [Wang Chien] (Chinese, 1598–1677). *Kakemono.* Qing dynasty, 1668. Watercolor, 53 5/16 x 24 5/8". Courtesy of the Freer Gallery of Art, Smithsonian Institution, Washington, D.C. 56.27

*The primary indicator of deep **space** in this Chinese landscape is the placement of the distant mountains above the closer ones. There is very little difference in scale among the buildings, although clearly some are meant to be farther away than others.*

130

Paul Cézanne (French, 1839–1906). *Turn in the Road*.
c. 1879–82. Oil on canvas, 23⅞ x 28⅞″. Courtesy, Museum of Fine Arts, Boston, Bequest of John T. Spaulding

*This landscape by the Post-Impressionist painter Cézanne
displays three devices typically used by European artists to
establish a sense of **space**. The first is linear **perspective**,
most clearly shown by the road, which seems wide at the
picture's edge and narrows as it goes back until its two sides
converge and disappear. Also, the trees in the foreground are
made larger than the ones in the background and the houses
overlap in order to indicate their placement in the distance.*

Michelangelo da Caravaggio (Italian, 1571–1610). *Supper at Emmaus*. c. 1600–1601. Oil on canvas, 54³/₄ x 76³/₄". National Gallery, London

*Note how the use of **chiaroscuro**, juxtaposing light areas with darker and shaded ones, helps pull the eye into and out of this scene. Follow the highlights and shadows and you will see that the light does not emanate from a single source; instead, light and shadow are used to **model** the figures, enhancing the space and drama of the picture. (Compare the related but more delicate technique of "sfumato"; see illustration, p. 146.) A sense of drama is also achieved above through the **illusionistic** technique of "foreshortening," the altering of proportions to make the outstretched arms of the figures seem to reach out of the painting toward the viewer.*

Advancing, Receding

Adjectives applied to **colors**, the use of dark and light contrasts, and the angles of **lines** or **planes** that make them appear to be moving toward us or sinking back into the picture's depths. See also **chiaroscuro.**

Background, middle ground, foreground

Many artists want to suggest the experience of looking through a window. We know that outside a window, some things we see are close by, some not so close, and some are off in the distance. In art, those things that seem most distant, as if at the back of the picture, are in the "background." Those closest to us are in the "foreground," and those in between are in the "middle ground," logically enough.

Chiaroscuro: light/shadow

An Italian term that literally combines words for "bright" and "dark," chiaroscuro refers to the device of contrasting light, bright areas of a picture with dark or shaded ones nearby. This can increase the sense of space: darks tend to be perceived as depths, in the way that the inner recesses of a closet are dark; lights, on the other hand, tend to move out from the canvas, toward the viewer, as when the sun catches our eyes as it sparkles on water. In this manner, **tones** tend to define the depth of **planes** within a picture: lighter ones seem closer, and darker ones press into the painting's **background**. In realistic work, this is usually done by suggesting a light source that "highlights" appropriate places, leaving others in gradually deepening shadows, a process referred to as **modeling** with light and shadow. Often artists contradict these expectations, playing with matters of perception to create optical tensions and make dramatic events more so. The effect can even suggest psychological overtones: for example, the Dutch artist Rembrandt frequently painted the eyes in his portraits (see p. 145) in deep shadow; the effect was to leave the impression of sadness, great calm, or wisdom.

Form

Refers to **volume** or a mass that takes up space, such as **sculpture**, and exists in a physical sense. To create forms, an artist must use **materials** (clay or stone, for example) with which to build up mass. Form also refers to images on flat surfaces that *appear* to have volume. In order to achieve this **illusion**, artists use techniques such as **modeling** or **hatching**.

The word "form" is often interchanged with **shape**. One way to distinguish between them is to think of shapes as only the outlines or the **contours** of something, flat like a silhouette, while forms have, or appear to have, volume.

Form can also be used to refer to different manifestations of something, as in a movie appearing in the forms of both video and film. **Prints** are one form of artistic expression, **sculpture** another.

As a verb, "forming" means to create something, as in transforming raw materials into art. In **casting**, a **mold** is sometimes called a "form."

Illusionism

Much **Western** art since **medieval** times has been concerned with making images appear "real." Artists have wanted to portray things we might experience in the physical world, as if looking through a window. Since most artists work on flat surfaces—such as paper or canvas—they employ a number of techniques to fool our eyes. For example, placement, **scale**, and alignment of objects (aspects of **perspective**) can make us believe in space within a picture. Slanted or blurred **lines** and certain **shapes** will suggest movement. **Color** contrasts can indicate highlights and shadows.

Modeling

In one sense, modeling is used interchangeably with **molding** to mean transforming a mass of material into an object, as in modeling clay. In art on flat surfaces, such as **painting**, modeling is a technique of using shadows, shading, and highlights to create

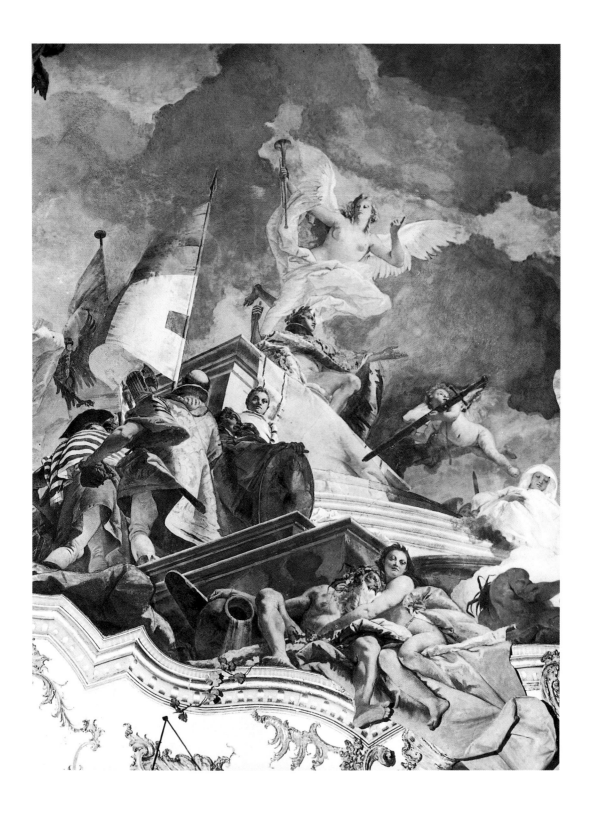

Giulio Troili da Spilamberto, called Il Paradosso (Italian, 1613–1685). *Position of Figures in Relation to Horizon.* 1672. Woodcut

Linear perspective *is achieved by a carefully worked-out mathematical system, as illustrated by painter and theorist Il Paradosso in his handbook on the subject.*

Opposite:
Giovanni Battista Tiepolo (Italian, 1696–1770). *Apollo Bringing Beatrice of Burgundy to the Seat of the German Empire* (detail). 1751. Ceiling fresco, 29'6" x 59'. Kaisersaal, Archbishop's Palace, Würzburg, Germany

Tiepolo was such a master of **illusion** *that he could confuse our eyes. Where does the architecture of this room begin and end? What is painted and what is actually there in three dimensions? At its extreme, this kind of mastery is referred to by the French term* trompe l'oeil, *which means to "fool the eye."*

Berenice Abbott (American, 1898–1991). *New York at Night.* 1933. Gelatin-silver print, 10½ x 12¾". The Museum of Modern Art. New York. Purchase

The **perspective** *of an image can also refer to the literal* **vantage-** *or* **viewpoint** *of the artist. The artist's vantage point is usually the one from which the viewer seems to see the image, as well. Cameras have made it simple to make images that involve extraordinary views, as we see here.*

the **illusion** of **forms** that are solid and have **volume**. Modeling can also refer to the act of a person posing ("sitting") for artists to draw or paint.

Perspective

One of the best-known techniques in **Western** art for creating believable depth in pictures. There are two types of perspective: "linear" and "atmospheric." The first involves a system of lines that converge at "vanishing points"—those places in the distance (say, the horizon) at which objects seem to disappear. The lines are diagonals, based on the principle that two parallel lines (reminiscent of railroad tracks) will appear to get closer together as they go off into the distance and to meet eventually at the vanishing point. This system is used to establish the **scale** of objects, which appear smaller as they move farther away. Atmospheric perspective involves making objects off in the distance less distinct—less "in focus"—in imitation of the eye's difficulty in seeing details accurately at distances (see illustrations, pp. 82, 138, for example).

Planes

The surfaces of a building or **sculpture**, usually referring to flat surfaces in particular. Part of creating spatial **illusion** in **two-dimensional** art is to make people forget that they are looking at a flat canvas or paper. One way to do this is to create a variety of apparent planes within a picture, such as the walls of a room or the facades of houses in the distance. See also **background.**

Scale

Refers to relative size: horses are relatively larger than dogs. It can also refer to relative proportion, as in the scale of a door being too large for a house.

Three-dimensional

Refers to a mass having height, width, and depth. **Illusionist** techniques may be used to create a sense of depth, or three dimensions, in a two-dimensional painting.

Two-dimensional

Refers to a mass having only height and width. The surface of a **canvas** or piece of paper, for example, is two-dimensional, or "flat."

Volume

In **sculpture**, this term refers to the amount of space a mass takes up. In **two-dimensional** art, volume refers to both the **illusion** of mass as well as the amount of space something appears to occupy.

TEXTURE

The look and/or feel of the surface of a work of art, which can range from smooth and/or shiny to rough and/or dull. The word can also refer to the tactile sense of **materials** depicted in an image, such as the raised "nap" of rough-woven cloth or the **patina** of metals.

Brushstroke

Marks made by brushes used to apply paint. Brushstrokes can be large and visible (see **impasto**) or tiny and hardly discernible, depending on the size and shape of the brush used. Traditionally, painters have blended such marks together, wanting to make their images look as "naturalistic" as possible. Exceptions to this include **calligraphy,** where the mark of the artist with his/her brush is the whole point of the art.

By the seventeenth century, artists in Europe realized that the way **paint** was applied could contribute meaning to a picture: brushstrokes themselves could give a painting energy and make a finished work look more alive. A smooth surface had one effect, a bumpy one another. In **modern** art, the brushstroke came to be seen as important in itself.

Gesture

Closely related to the concept of **brushstroke**, gesture is the permanent imprint ("gesture" or "mark") of the artist's hand on a work, providing an insight into the artist's way of working and emotional intentions. **Expressionist** art is particularly likely to show such marks indicating the actions taken by the artist; in fact, another name for Abstract Expressionism is "Action painting." In an opposing trend in late **modern** art, **Minimalist** artists went to great lengths to avoid any mark of the maker in order to emphasize rationality over emotion.

The term "gestural" can be applied to **paintings**, **drawings**, and **prints** in which brushstrokes or other marks ("gestures") are clearly apparent. See also **dynamism**, **linear**, and **painterly**.

Impasto

Paint that has been applied thickly, perhaps built up in layers, to create rough spots in the surface texture. Artists such as Rembrandt (see p. 145) layered white paint when highlighting areas, which caused the highlights to pick up and reflect light cast on the painting. This both increased the brightness in those spots and enhanced their suggested **volume**. Heavy impasto became a hallmark of certain **modernists** who felt that the gooey thickness of paint gave distinct emotional charge to their paintings.

Painterly

A way of painting that takes advantage of the thick wetness of paint as it is applied. In "painterly" paintings, even after the paint hardens, there is a thick, creamy surface. Since the paint is thus very obvious and noticeable, it is fairly easy to discern strokes of the brush, layers, and mixes of **colors**. See also **brushstroke** and **impasto**.

SUBJECT MATTER AND CONTENT

"Subject" refers to what artists make pictures of—the things they depict. For example, the subject of a painting can be a person or a bowl of fruit arranged with several other objects on a table. On one level, the subjects are easy to determine. They become harder to read, however, when an object stands for something beyond itself. For example, if the fruit in a bowl seems overripe, we might conclude that it is about to decay, which might be a metaphor for advancing age. Therefore, the subject or subject matter of a painting can be both what you see *and* what the image might be about in a larger sense. The term "content" is often used when referring to what an art object seems to be about in the larger, more complex sense.

In one sense, you can say that the subject of **abstract** art cannot be pinned down. It can be anything you make of it. In another sense, it can be about **shapes**, or **colors**, or relationships between them. In yet another, it can be about the effect of how **materials** are used. **Painting** very carefully can give one impression, while quick, fast **brushstrokes** can convey quite another sensation.

Allegory

A story or concept—including one in art—represented **symbolically.** While seeming to be about one thing, often something simple, allegorical art addresses larger social or moral issues: events, objects, and even people are presented as symbols of ethical or religious principles or unspoken ideas. For example, observe how the striding pose and swirling drapery of the *Winged Victory* (p. 27) convey a sense of strength and triumph, heightening the figure's symbolic meaning.

Figure

From earliest recorded history, the human form has been a **subject** of art. Royalty, gods/goddesses, mothers, children, warriors, hunters, as well as spirits, seasons, suns and moons, the Earth: all have at one time or another been represented in illustrations as figures. Some have combined animal, human, and even fantastic features. Some have

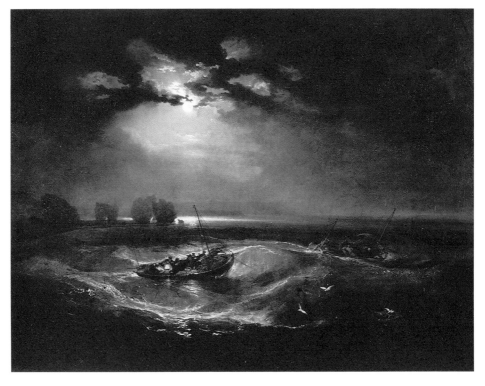

Opposite, above:
Thomas Cole (American, b. England, 1801–1848). *View Near the Village of Catskill*. 1827. Oil on canvas, 24½ x 35". The Fine Arts Museums of San Francisco, Gift of Mr. and Mrs. John D. Rockefeller 3rd, 1993.35.7

Opposite, below:
J. M. W. Turner (English, 1775–1851). *Fishermen at Sea*. 1796. Oil on canavs, 36 x 48". Tate Gallery, London

Landscapes *can take on myriad forms. To see how styles and mediums change with time and with the intentions of the artists, compare the examples on these two pages with other land-, sea-, and cityscapes illustrated throughout the book.*

Romare Bearden (American, 1914–1988). *Black Manhattan*. 1969. Collage of paper and synthetic polymer paint on composition board, 22⅛ x 18". Schomburg Center for Research in Black Culture, Art and Artifacts Division. The New York Public Library. Gift of Mr. and Mrs. Theodore Kheel

Canaletto (Giovanni Antonio Canal, Italian, 1697–1768). *The Thames and the City of London from the Dining Room of Richmond House*. 1747. Oil on canvas, 42½ x 46". From the Goodwood House, by courtesy of the Trustees

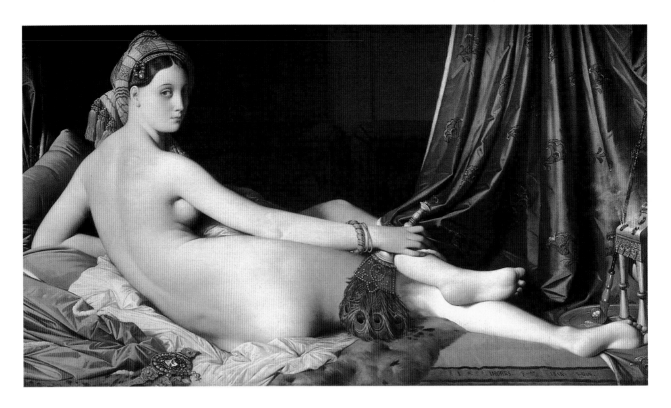

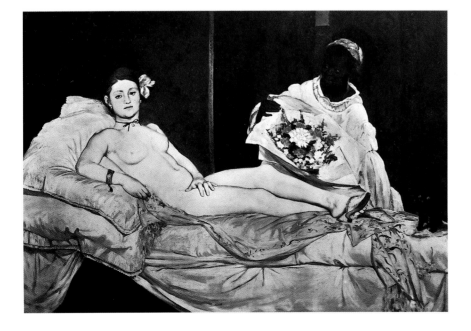

Jean-Auguste Dominique Ingres (French, 1780–1867). *Odalisque*. 1814. Oil on canvas, 35¼ x 63¾". Musée du Louvre, Paris

Left:
Edouard Manet (French, 1832–1883). *Olympia*. 1863. Oil on canvas, 51 x 75". Musée d'Orsay, Paris

*By studying the way the **figure** is shown and comparing different representations, we can observe contrasting approaches and ideas among artists as well as times and cultures. Although similar in subject and painted only fifty years apart, these two representations of nude women contrast sharply in the attitude each conveys: compare the coyness of the pose and protective fan in Ingres' work with the matter-of-fact gaze and placement of the hand in the Manet.*

been **idealized**; others **stylized**, or "caricatured"—characterized by certain recognizable features that have been exaggerated or distorted. Some are presented without clothing ("nudes"). Some figures are **portraits** of specific people, others likenesses of the artists who created them (**self-portraits**). Still others are "personifications" of nonliving objects or abstract ideas. The figure can be sketched quickly, **rendered** with careful attention, or "refigured" in an imaginative manner, as in **Cubism**. When something is called "figurative," the meaning tends to go beyond people to include any recognizable **form**.

Genre
In art, "genre" is used two ways. Most often the term indicates **subjects** that have to do with ordinary people engaged in everday activities. It also can refer to a category, such as painting.

Iconography
A language of **symbols**. When an idea appears in pictures, it may be represented by an image, as in the dove as a symbol of peace. Religious art uses picture codes to represent particular **figures**, moral virtues, and/or specific messages—for example, a hand gesture to say "come to me." An individual artist might also have a personal set of images that represent certain ideas or impressions and appear repeatedly in his or her work. We examine iconography in order to learn more about the ways ideas have been developed and represented throughout history.

Landscape
Work of art that depicts a scene in nature, the suffix "scape" meaning "view of. . ." The word "landscape" can refer to any natural scene, although some art historians use it only with reference to views of the countryside, adding the terms "seascape" to include open water and "cityscape" for buildings and city life.

Portraits
While a **figure** can be anyone, and is often generalized on purpose, a portrait tries to present both an accurate depiction and to some degree other aspects of a particular person's character—personality, for example, or moral goodness or authority.

Self-Portrait
Artists often make themselves the subject of their work in "self-portraits." They can do so by looking in a mirror—resulting in an intense gaze we can often recognize in the finished work—or perhaps by using a painting or photograph of themselves as a model.

Still Lifes
Pictures of objects—typically bowls, vases, bottles, pitchers, sometimes letters and books—as opposed to **figures** or **landscapes** (the latter category often includes natural objects such as fruit and flowers, but usually they are still growing in nature); sometimes recently killed game; and occasionally even weapons or skulls. On an obvious level, still lifes offer artists the opportunity to study a **subject** over time, concentrating on reproducing the look of different **materials**, **colors**, **light**, **textures**, and placement in **space**. Artists also use still lifes to study and construct careful **compositions**. On a more **symbolic** level, artists can be thinking about relationships between humans and nature, or about how things of beauty eventually decay and death inevitably advances, as seen in the Dutch "vanitas" still lifes of the seventeenth century. (See illustration, p. 143.)

Alice Neel (American, 1900–1984). *Two Black Girls*.
1954. Ink and gouache on paper, 29 x 21½″. Private
collection

Hans Bollongier (Dutch, 1600?–1644?). *Still Life with Flowers*. 1639. Oil on oak panel, 26³/₄ x 21¹/₂". Rijksmuseum, Amsterdam

Opposite:
Frida Kahlo (Mexican, 1910–1954). *Self-Portrait with Monkey*. 1938. Oil on masonite, 16 x 12″. Albright-Knox Art Gallery, Buffalo, New York. Bequest of A. Conger Goodyear, 1966

Rembrandt van Rijn (Dutch, 1606–1669). *Self-Portrait*. 1660. Oil on canvas, 45 x 37¹/₂″. The Iveagh Bequest, Kenwood House, London

*By comparing any group of works of the same subject— for example the **portraits** and **self-portraits** on pp. 142, 144, 145, and throughout this book—we can learn more about the wide variety of styles, compositions, and other techniques used by different artists.*

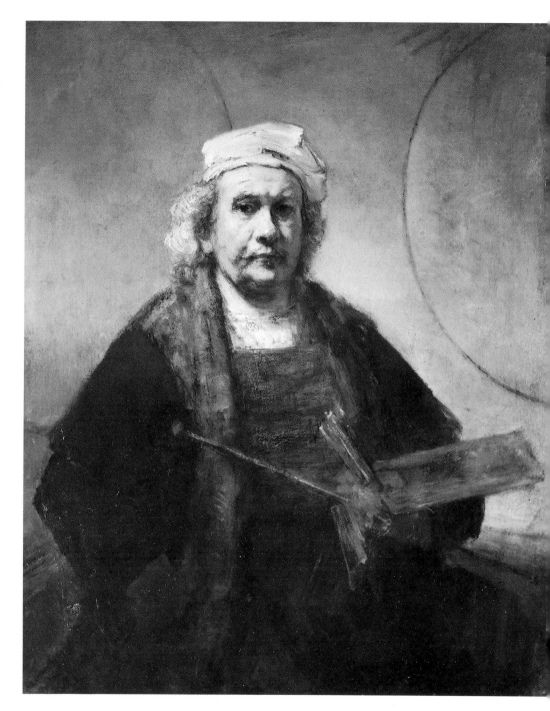

Afterword: What Makes Art "Great"?

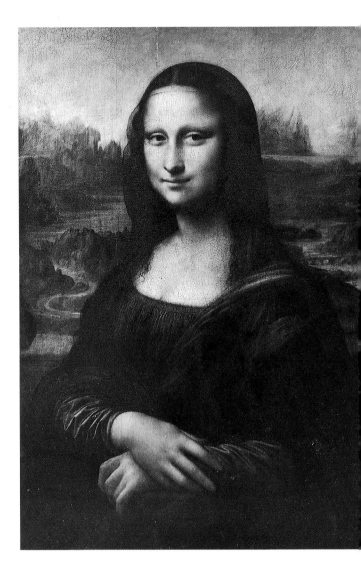

A "masterpiece" is a work honored by critical opinion over time, usually considered a pinnacle of **aesthetic** achievement by an important artist. The term derives from "master" as it was conferred on one who was supremely accomplished in a field within the structure of the European **medieval** "guilds"—systems of training through apprenticeship. Masterpieces are judged by comparison to others in the same category, **period**, **style**, or **school**. They·are often valued so highly by the knowledgeable that they become the best-known, and therefore the most influential, works of a period, sometimes overshadowing other works of merit. Because it has a masculine **Western** connotation, the term is less often used in recent discussions.

Judgment of quality, however, remains a difficult matter. Vincent van Gogh (see p. 69) was ignored during his lifetime and certainly not thought of as a good artist. Now he is considered one of the greatest. Even highly informed views and staunchly held values change over time. Experts tell us that Leonardo da Vinci's *Mona Lisa* is a masterpiece, an opinion we may accept with or without much consideration. The figure by an unnamed artist of the Kota people of **Africa** is also acclaimed as the work of a master. Yet they seem so different. How do experts judge them? How can *we* get to the point of making artistic judgments that are knowledgeable, objective, and still account for our own values and views?

Any work of art deserves to be examined thoughtfully and, perhaps, researched before we finally arrive at conclusions—a process that takes time. First we must determine what is going on in the work, thinking about what the **subject** means to *us*. Then we should think about each of our responses and examine the work again, separating purely personal associations from responses that are more objective, grounded in evidence we see in the

146

Opposite:
Leonardo da Vinci (Italian, 1452–1519). *Mona Lisa (La Gioconda)*. 1503–7. Oil on panel, 30¼ x 20⅞″. Musée du Louvre, Paris

Guardian figure. Gabon. Kota, 19–20th century. Wood, copper, and brass, 26¾″. Private collection

Marcel Duchamp (French, 1887–1968). *L.H.O.O.Q.* 1919. Rectified Ready-Made, pencil on reproduction, 7³/₄ x 4⁷/₈". Private collection, Paris

The Dada artist Marcel Duchamp took one of the most revered paintings in history and, in a graffiti-like gesture, drew a moustache on the quiet figure of Leonardo's Mona Lisa. *Does it make sense to call this art? It might if you think of the time in which it was made—its context: World War I left Europe with a great deal of its past in ruins, with a new era's "make it new" attitude, as well as a tendency to debunk tradition and convention and a desire to make one's own mark ("Kilroy was here . . ."). Maybe awed by the accomplishments of earlier artists, maybe bored with the present, maybe making fun of the way art had become something precious for itself not for what it meant, Duchamp took this funny, irreverant step toward a new art of irony and nonsense—matching much of what he saw around him.*

artwork. The process involves breaking art down into parts—such as **materials**, **composition**, and **craftsmanship**—to see how each contributes to the whole. We can build a case for what the artist's intentions might have been—including the implications of titles. We must look at a work in the appropriate **context**, seeking additional information regarding the **culture** from which it comes. We need to compare it to works that are both similar and different. We must see many works by one artist to trace what happens over time, many within a single style in order to understand all of its nuances, or many of the same subject in order to see how different artists from a variety of cultures deal with it.

We also need to consider what an artwork reveals to us—its values. Does it enrich us in any way, telling us something we need to know, or something in a new way? Does it make both our minds and emotions respond? Does its content seem important or profound? And, very important, does it sustain our interest over time?

The final images in this book dramatize how art can "work" for us today—and in ways we may not expect. Picasso's *Les Demoiselles d'Avignon* (an image of prostitutes posed in a bordello) was a painting he labored over. He was unsure of it, and for a long time he kept it in his studio, trying to come to terms with what he had done. It is easy to understand his consternation—the painting is certainly not beautiful; in fact, it looks awkward. Yet Picasso's friend the artist Georges Braque saw it as a breakthrough, an opinion that has since come to be acknowledged generally. Picasso's innovation involved the breaking up of forms (figures, furniture, a bowl of fruit) into planes, with little regard for volume and ignoring most European conventions used to create believable space. These are hallmarks of what we now know as **Cubism**, a way of painting—and of understanding art—that continues to influence artists today.

Picasso's influence is obvious in the painting *Les Demoiselles d'Alabama: Vestidas* ("Dressed").

Picasso's work was a conscious inspiration for **postmodern** artist Robert Colescott. To appreciate Colescott's motivations, look at what he has changed, for example, the bright colors he added to charge his image with energy. Colescott's figures are no longer nude—a convention since **ancient** times that tends to depersonalize. Their clothes give the figures individual personality and set them in the present. Picasso's flattened women are crammed in a shallow space; Colescott's appear to be outdoors, perhaps on a picnic, and they are voluptuous—a quality we might expect in reality but not within the Cubist style. Picasso's **stylized** women hint at a quality of caricature that in Colescott's hands takes on an acid bite. If Picasso's masklike faces merely allude to mixed races, the stereotyped features of Colescott's women leave no doubt. What are the implications of this? Colescott seems to be treading territory as risky from a social standpoint as Picasso's was aesthetically.

The point of this brief, and incomplete, comparison is that these two works are both inspirational in a very twentieth-century way. Whether we are examining an artwork to see what it brings to our world, and perhaps why; or we are trying to learn about a style, an artist, or a historical period; or we are musing on originality, creativity, and the meaning of art, we are *thinking*. At various times art has been about everything from beauty, magic, and myth to religion and history—and often it still is. Today, however, a primary function of art both past and present is that it engages our minds (and usually our hearts as well) critically and creatively, even if provoking anger or confusion. Coming to terms with the challenges provided by Picasso or Colescott is demanding and exciting in and of itself. Trying to understand what the two artists mean to each other, as well as in terms of their own times, and again at this moment when we can see them together, is more than just an exercise, however. Using our intelligence in this imaginative and comprehensive way is what makes us human.

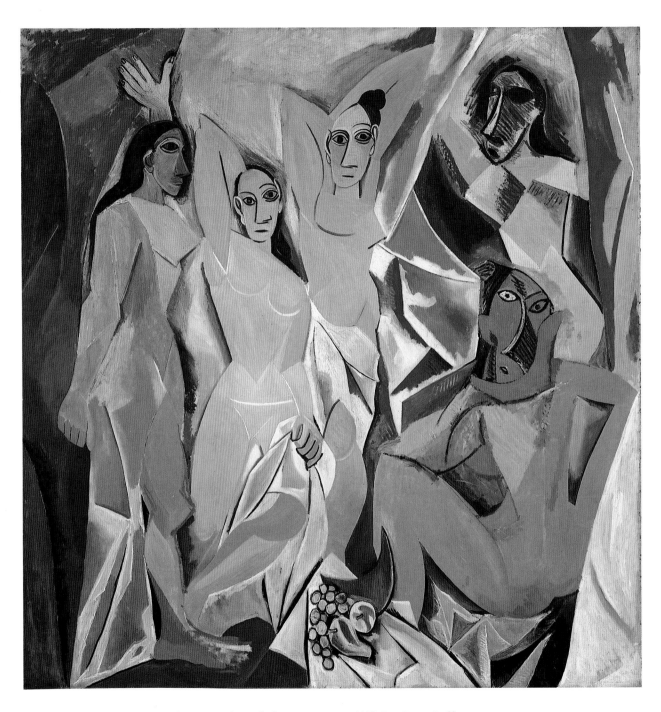

Pablo Picasso (French, b. Spain, 1881–1973). *Les Demoiselles
d'Avignon*. 1907. Oil on canvas, 8′ x 7′8″. The Museum of Modern
Art, New York. Acquired through the Lillie P. Bliss Bequest

Robert Colescott (American, b. 1925). *Les Demoiselles d'Alabama: Vestidas*. 1985. Acrylic on canvas, 96 x 92". Private collection, New York. Courtesy of Phyllis Kind Gallery, New York/Chicago

Selected Bibliography

Baker, Joan Stanley. *Japanese Art.* London: Thames & Hudson Ltd., 1980.

Braun, Barbara. *Pre-Columbian Art and the Post-Columbian World: Ancient American Sources of Modern Art.* New York: Harry N. Abrams, Inc., 1993.

Columbia Encyclopedia. 5th ed. New York: Columbia University Press and Houghton Mifflin Company, 1993.

Craven, Roy C. *Indian Art: A Concise History.* London: Thames & Hudson Ltd., 1976.

Franch, José Alcina. *Pre-Columbian Art.* Translated by I. Mark Paris. New York: Harry N. Abrams, Inc., 1983.

Janson, H. W. *History of Art: A Survey of the Major Visual Arts from the Dawn of History to the Present Day.* 4th ed. Revised and expanded by Anthony F. Janson. New York: Prentice Hall, Inc., and Harry N. Abrams, Inc., 1991.

Kerchache, Jacques, Jean-Louis Paudrat, and Lucien Stephan. *Art of Africa.* Translated by Marjolijn de Jager. New York: Harry N. Abrams, Inc., 1993.

Lee, Sherman E. *The History of Far Eastern Art.* 5th ed. New York: Harry N. Abrams, Inc., 1994.

Richardson, E. P. *A Short History of Painting in America: The Story of 450 Years.* New York: Thomas Y. Crowell Company, 1963.

Rosenblum, Robert, and H.W. Janson. *19th-Century Art.* New York: Harry N. Abrams, Inc., 1984.

Thompson, Robert Farris. *African Art in Motion: Icon and Act.* Berkeley: University of California Press, 1974.

Tregear, Mary. *Chinese Art.* London: Thames & Hudson Ltd., 1980.

Index

Page numbers in *italics* indicate illustrations and/or captions.

Photograph Credits

Numbers in **bold** refer to page numbers.

Page 7: George Holton/Photo Researchers, Inc.; **9, 12, 77, 115, 117, 140** (above, below), **146:** © R.M.N., Paris; **11** (A109327c), **116** (A111431c): The Field Museum, Chicago; **15** (right): Jim Frank; **15** (left): © Sam Shaw; **20, 23:** Charles Uht; **24, 70:** Geoffrey Clements; **27, 47, 48** (above, below): Hirmer Verlag, Munich; **28** (left), **30, 87:** MAS (Arxiu Mas), Barcelona; **28:** Steven Tucker; **32:** © Jane Lidz; **34:** Courtesy Mary Boone Gallery, New York; **35** (photo: Philips/Schwab), **142:** Courtesy Robert Miller Gallery, New York; **37:** Soichi Sunami; **38:** From *Stone,* by Andy Goldsworthy, Harry N. Abrams, Inc., 1994. © Andy Goldsworthy and Cameron Books; **39:** Philip Pocock; **43:** Michel Monteaux; **45** Courtesy Tony Shafrazi Gallery, New York (photo: Tseng Kwong Chi); **51:** Courtesy Holly Solomon Gallery, New York; **56** (below): © Peter Aaron/ESTO; **56** (top): China Pictorial, Beijing; **57:** Courtesy Pace Wildenstein, New York; **59:** © The Solomon R. Guggenheim Foundation, New York; **60:** Japan National Tourist Organization; **68, 85** (above), **96** (photo: Christopher Gallagher): Photograph © 1995, The Art Institute of Chicago. All rights reserved; **74:** Ferdinand Anton, Munich; **76:** Boltin Picture Library; **77:** SCALA/Art Resource, New York; **78:** Gaetano Barone, Florence; **80** (right), **90** (below), **99:** Alinari; **80** (left): Fototeca Unione, Rome; **81:** Caisse Nationale, Paris; **82:** Lauros-Giraudon, Paris; **85** (below): NHK, Tokyo; **94:** Jörg P. Anders; **98** (left): David Finn; **102, 121** (left): Lee Stalsworth; **103** (left): Wim Swaan; **103** (right): Barbara Braun; **105:** David Wharton, Dallas; **109:** Kenneth Lester; **110:** John Betancourt, Santurce, Puerto Rico; **128:** Kate Keller; **132:** John Webb; **143:** © Rijksmuseum-Stichting, Amsterdam (photo: Gundermann, Würtzburg); **138:** The Clore Collection, Tate Gallery, London/Art Resource, New York (photo: John Webb); **144:** Courtesy Albright-Knox Art Gallery, Buffalo, New York; **148:** Courtesy Philadelphia Museum of Art; **151:** Courtesy of Phyllis Kind Gallery, New York/Chicago. Back cover (below left): Photograph © 1995 The Museum of Modern Art, New York.

Artwork Copyrights

© 1995 Artists Rights Society (ARS), New York/ADAGP, Paris: **10, 21, 36, 52, 84, 105, 125, 148;** © 1995 Artists Rights Society (ARS), New York/SPADEM, Paris: **61, 98, 150** and back cover (below left); © 1995 Artists Rights Society (ARS), NewYork/Pro Litteris, Zurich: **37;** © 1995 Artists Rights Society (ARS), New York/VG Bild-Kunst, Bonn: **94;** © 1995 Artists Rights Society (ARS), New York/Bono, Oslo: **98** (left); © 1995 Succession H. Matisse, Paris/Artists Rights Society (ARS), New York: **2;** © 1995 Willem de Kooning/Artists Rights Society (ARS), New York: **15;** © 1995 The Estate of Keith Haring/Artists Rights Society (ARS), New York: **45;** © 1995 Pollock-Krasner Foundation/Artists Rights Society (ARS), New York: **58;** © 1995 Mike & Doug Starn/Artists Rights Society (ARS), New York: **77;** © 1995 The Munch Museum/The Munch-Ellingsen Group/Artists Rights Society (ARS), New York: **41;** © 1995 Andy Warhol Foundation for the Visual Arts/Artists Rights Society (ARS), New York: **14;** © Barbara Kruger: **24;** DACS/V.A.G.A., New York: **66;** © 1995 Marisol/V.A.G.A., New York: **70;** © 1995 Robert Rauschenberg/V.A.G.A., New York: **88;** © 1995 Estate of David Smith/V.A.G.A., New York: **121** (left); Printed by permission of the Norman Rockwell Family Trust. Copyright © 1960 the Norman Rockwell Family Trust: **104;** © Addison Gallery of American Art, Phillips Academy, Andover, Massachusetts. All rights reserved.: **120;** © Estate of Isamu Noguchi: **121** (right); © Berenice Abbott/Commerce Graphics Ltd., Inc.: **135** (right); © Estate of Romare Bearden: **139;** © Estate of Alice Neel: **142.**

Dedicated to

Abigail Housen and
Andrew Richard Everly

Editor: Harriet Whelchel
Designer: Darilyn Lowe Carnes
Photo research: Neil Ryder Hoos

Library of Congress Cataloguing-in-Publication Data
Yenawine, Philip.
 Key art terms for beginners / by Philip Yenawine.
 p. cm.
 Includes bibliographical references and index.
 ISBN 0–8109–1225–2
 1. Art—Terminology. 2. Art appreciation. I. Title.
N34.Y46 1995

 94–26911

701′.4—dc20

Text copyright © 1995 Philip Yenawine
Illustrations copyright © 1995 Harry N. Abrams, Inc.

Published in 1995 by Harry N. Abrams, Incorporated,
New York

Printed and bound in Hong Kong
10 9 8 7 6 5 4

The cover images are reproduced, with captions, on the
following pages: Front, clockwise from top left, 144, 146,
103, 116; back, clockwise from top left, 55, 77, 96, 151, 150

Acknowledgments

For research, Neil Hoos, Steve McLean, Coco
McPherson, and Tara Geer; for additional sugges-
tions: Rebecca Yenawine and Patricia Yenawine; for
an elegant design, Darilyn Lowe Carnes; for superior
editing and all that goes with that job, Harriet
Whelchel; for moral support, Harry and Eban Lasker
and Olivier Renaud-Clément.

P.Y.

Harry N. Abrams, Inc.
100 Fifth Avenue
New York, N.Y. 10011
www.abramsbooks.com

Abrams is a subsidiary of